FIRST IMPRESSIONS

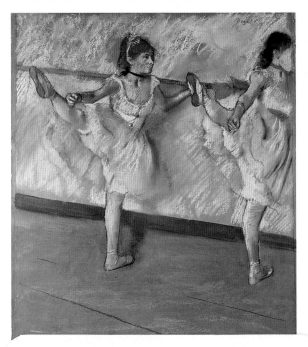

5/95

DEMCO

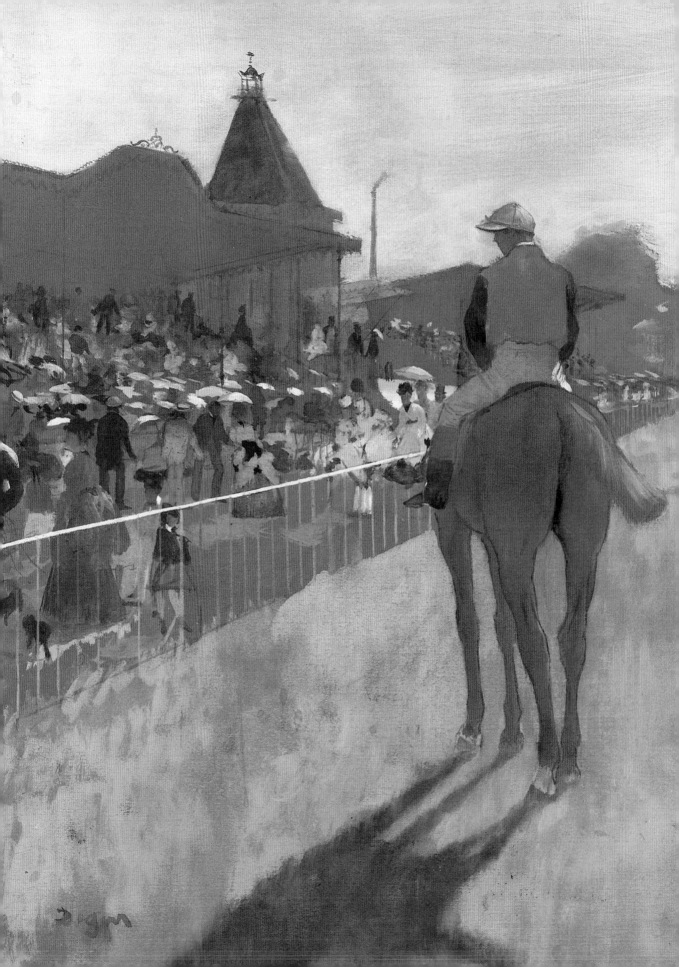

First Impressions

Edgar Degas

Susan E. Meyer

Harry N. Abrams, Inc., Publishers

For Myriam Sedel and to the memory of Fred

EDITOR: Robert Morton
DESIGNER: Joan Lockhart
PHOTO RESEARCH: Catherine Ruello

Library of Congress Catalog Card Number: 94–8420
ISBN 0–8109–3220–2

Published in 1994 by Harry N. Abrams, Incorporated, New York
A Times Mirror Company

Printed and bound in Hong Kong

Chapter One

YOUNG MONSIEUR DEGAS

Edgar Degas was full of contradictions. Almost nothing about him made sense except his art. Just think: Degas was not merely acquainted with the Impressionists (considered a bunch of radical artists at the time), he was actually one of their *leaders*. Even though he joined this revolutionary group, Degas was very conservative when it came to just about everything else. He was a respected member of the established upper middle class, with old-fashioned ideas about politics, women, and how society should be run.

It's also curious that although he was one of the most loyal members of the Impressionists, he actually shared very few of their ideas about art. While the others were turning their backs on tradition, he drew his inspiration from the past, from the Old Masters of the fifteenth and sixteenth centuries. While the others were painting landscapes outdoors, he was painting figures indoors. While they worked on the spot, he worked in his studio from memory and sketches.

SELF-PORTRAIT IN A SOFT HAT. *1857.*

Painted while Degas was in Rome, the artist reveals himself as a grave young man experiencing the kind of inner conflicts that would haunt him throughout his life.

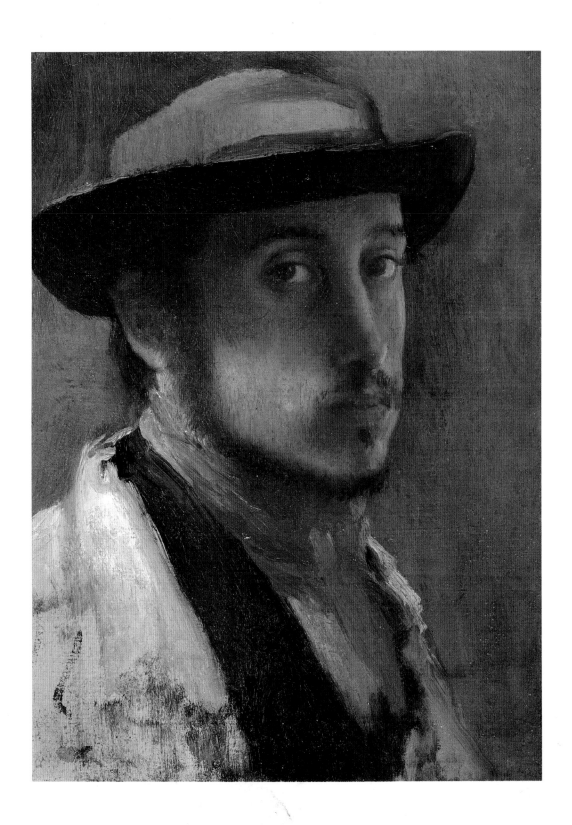

SELF-PORTRAIT. *1857.*

A friend of Degas noted, "His raised brows and heavily lidded eyes gave him an aspect of aloofness."

While they fussed about color, he concentrated on drawing. Degas even despised the term "Impressionist."

Looking at Degas' paintings, it's hard to imagine that the man who depicted those lovely ballerinas and hard-working laundresses with such sympathy and understanding was the very same man who frequently made unkind remarks about women. He was changeable: one moment he could be brusque and rude, for example, and the next charming and generous. He declared a preference for solitude, yet he socialized almost every evening. He had no room for marriage, yet he often yearned for family and had several close female friends over the years. In his later years he revealed himself to be a fierce anti-Semite, breaking with many of his friends over a scandal involving a Jewish military officer named Alfred Dreyfus. And this happened even though his closest friend since boyhood, Ludovic Halévy, was Jewish.

Degas actually seemed to enjoy antagonizing people, always grumbling about this or that, yet he was beloved by his family and friends for his loyalty and steadfast friendship. Morose as he often appeared, he could be extremely funny at times. It was also ironic that this great artist—who had such an eye for detail, who was driven to perfect even the most minute passage in his work, who seemed able to see what others could not—was afflicted with very poor eyesight.

One thing is clear: Edgar Degas was a man at odds with himself. Torn by uncertainty and doubt, yet extremely opinionated on just about every subject, Degas managed to find a haven in his studio. Here was the place where he flourished, where his spirits soared every working day until the dimming light forced him to set aside his tools. Maybe his internal conflicts drove him to perfect in the studio what he could not perfect in his personal life. In the end, his relentless perfectionism has given us some of the greatest paintings of the nineteenth century.

In Paris, France, on July 19, 1834, Auguste Degas and his wife, Célestine, announced the birth of their first child, Hilaire-Germain-Edgar, whom they simply called Edgar. The other names, Hilaire and Germain, came from Edgar's two grandfathers, who were both colorful men of awesome character. René-Hilaire, his grandfather on his father's side, had fled suddenly from France because he was suspected of being a political troublemaker. After many adventures, he eventually wound up in Naples, Italy, where he married his boss's lively young daughter and began to amass a fortune as a banker and real estate operator. They had seven children and lived in an enormous 100-room villa in the center of Naples. René-Hilaire's three younger sons worked in the bank in Naples and the eldest son, Auguste (Edgar's father), was sent to run the bank's office in Paris.

Germain Musson was Edgar's grandfather on his mother's side. He, too, was an adventurer and self-made businessman. Born on the island of Haiti, Germain decided to seek his fortune elsewhere. After traveling to Mexico, he settled in New Orleans, Louisiana, where he married the American daughter of a prominent French family, and built a financial empire by exporting cotton to the textile mills in Massachusetts and by mining silver in Mexico. When his wife died suddenly, he abandoned all this and took his five children to live in Paris.

It was in Paris that Germain's youngest daughter, Célestine, met and married Auguste Degas. Shortly after the wedding, Germain Musson went back to New Orleans, returning to visit Paris only once, at the birth of his grandson Hilaire-Germain-Edgar Degas.

While this family heritage was certainly prestigious enough, some of Edgar's

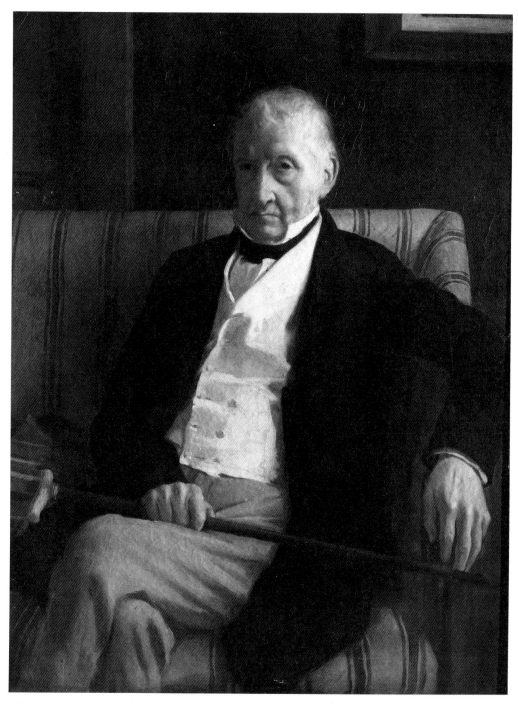

PORTRAIT OF RENÉ HILAIRE DEGAS. *1857.*

Degas' grandfather was a dynamic figure who ruled his family from Naples like a king.

relatives began to inflate the family name by breaking it into two words— "de Gas" or "De Gas"—which was a way of suggesting they were members of the aristocracy. Even Edgar signed his name de Gas until he was in his thirties. He then returned to plain "Degas," claiming that he couldn't possibly be mistaken for nobility because aristocrats never had to work, and he did.

In later years Edgar Degas did not talk much about his childhood, but his home seems to have been rather unhappy. His mother was only seventeen when she married Edgar's father and probably wasn't prepared to accept the settled life of a married woman or the exhaustion of bearing children. After Edgar she gave birth to seven babies, only four of whom survived—two boys, Achille and René, and two girls, Thérèse and Marguerite. Years later, a friend of Degas repeated a story the artist had told him about a typical scene at the dinner table: "His mother, being annoyed at something his father said, would drum her fingers irritably on the edge of the table, saying, 'Auguste! Auguste!' His father would sit tight until the meal was over, then sidle through the door, fling a cape around his shoulders, and glide noiselessly downstairs."

Edgar's father was not any more suited for his profession as a banker than for his marriage to a temperamental young woman. He seemed to prefer the company of artists and musicians and playing the piano or organ.

Edgar was probably tutored at home until he went off to the Lycée Louis-le-Grand, a boarding school in Paris that was considered the most prestigious in the country. Like all high schools of the day, Louis-le-Grand was exclusively for boys and Edgar's friendships with three other students—Henri Rouart, Paul Valpinçon, and Ludovic Halévy—remained lifelong. Here he received rigorous training in French literature, in the classics, in music, and in drawing. Although the school was very strict and the living conditions austere, Edgar found a certain comfort in being away from home, particularly after his mother died during his second year at the school, when he was only thirteen years old.

Almost certainly Edgar acquired his taste for art from his father. On Sunday mornings Auguste Degas would walk over to the Louis-le-Grand school to take his son on an outing in Paris. They would visit the great French national museum,

the Louvre, or wander through art galleries, or they would pay a visit to one of his father's several friends who collected paintings and drawings.

In 1853 Edgar completed his studies at Lycée Louis-le-Grand and passed the immensely difficult *baccalauréat* examination to receive a degree that at the time very few French men ever dreamed of achieving. (Women weren't even allowed to take the exam.) Armed with this degree, he could apply to any university of his choice, but to appease his father he registered at the law school. He left the school after the first term.

Auguste Degas recognized that his son was not cut out for the law, and did not protest when Edgar announced that he had been copying the works of the great masters at the Louvre and now wanted to enroll in art school.

Edgar began a course of study that was expected for any artist wanting to succeed: he registered at the most important art school in the country (some said the world), the Ecole des Beaux-Arts (School of Fine Arts) in Paris. But Edgar disliked the tense and competitive atmosphere of the classes, where the petty jealousies among the students and the whisperings of gossip intruded upon his concentration, and he dropped out after only a few months. He preferred to study in the atelier of Louis Lamothe, an artist who took in only a few students at a time. In the afternoons Edgar went to copy artworks at the Louvre, where the rooms were crowded with talkative students seated on their stools and working feverishly at their easels. For Degas, this was the best instruction: to look closely at the effects the Old Masters had achieved with their oil colors and to attempt to repeat these on his own canvas, a process that developed the skills of both eye and hand.

For two years the shy, sensitive, serious Edgar Degas applied himself to his studies. He had few friends and actually appeared to prefer being alone. He wrote in his diary: "It seems today that if you want to work at art seriously and make an original niche for yourself, or if you want at least to retain an unblemished personality, you must steep yourself in solitude."

In spite of his reserve, however, he was inevitably seduced by the many attractions Paris offered to a young man with money in his pocket. He discovered the

exciting night-life of Paris, the marvelous spectacles that would continue to attract him for years to come: the opera, the theater, the ballet, the concerts at the cafés, the performers, the circus, the lights. It did not occur to him at the time—nor would it have occurred to any artist of the day—that these were subjects to paint. What an artist painted in the studio was not related to modern life. The studio was where you continued the time-honored traditions of painting portraits, historical scenes, and subjects from classical history and mythology. Paris was a city for living, but not a subject for painting.

In the summer of 1855, Degas enjoyed an extensive holiday in the south of France, his first trip on his own. The experience was so stimulating that he decided to study in Italy the following year. Although Paris was considered the artistic

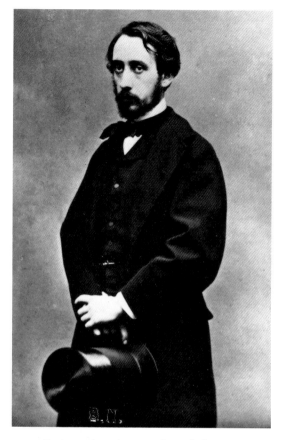

Seen in this photograph made between 1855 and 1860, Degas, although shy, was always stylishly dressed, as was expected of a man who came from a wealthy, cultured family.

capital of the world, a magnet that drew artists from everywhere, Italy continued to attract serious-minded art students. Here were the great churches, museums, and palaces where the most famous paintings of the Old Masters of the fifteenth and sixteenth centuries could be seen and copied. For Degas there was the added attraction of becoming better acquainted with his Italian relations.

He had plenty of opportunity to meet his relatives in 1856, when he went to

his grandfather's home in southern Italy. Here sixteen other members of the Degas family came to pass the summer at an enormous villa in San Rocco di Capodimonte, near Naples. During the two summers he spent there, Degas made numerous portraits of his relatives, including an oil painting of his grandfather, now elderly but still tough and determined. When he wasn't making portraits, Degas was sketching the ancient statues and copying paintings at the National Museum in Naples. "Let me get it well into my head," he wrote in his journal, "that I know nothing at all. That's the only way to make progress."

Degas spent the winters of 1856 and 1857 in Rome, where he continued to apply himself to his studies, but without the pleasant distractions of his lively family. He often fell into despondency, working to the point of fatigue, and complaining, "Oh how doubt and uncertainty tire me!" Only work seemed to calm him. "I want to try to keep busy all the time," he wrote in his diary. In Italy he expressed his despair openly, without resorting to the gruff and bitter manner that he adopted as an older man. "Great patience is needed on the hard road I've undertaken," he wrote to a friend. "Whatever affection you have for your family, whatever passion for art, there is a void which even that can't fill."

In spite of these worries, Degas referred to his time in Italy as the most extraordinary period of his life. He was independent for the first time and had no shortage of funds. He became devoted to his Italian relatives, and he joined a group of artists in Rome whose company he found stimulating and challenging. His Italian was fluent and his diligent study of the Italian masters gave him greater confidence in his skills as an artist. All these aspects of his time in Italy are summed up in his large family portrait of his Florentine relatives, the Bellellis.

Rather than return to Naples during the summer of 1858, Degas made a leisurely trip farther north to the city of Florence, where his favorite aunt, Laura, lived with her husband, Baron Bellelli, and their two children. He spent the entire winter of 1858 at their home, making drawings of the four family members. During his stay there he fell in with a noisy group of Italian painters sarcastically called the Macchiaioli, or "spot painters," because they painted effects of light and shadow by dabbing spots of contrasting colors on their canvases. Meeting

regularly at a crowded Florentine café, these artists loudly challenged all the ancient traditions of Italian art, determined to be liberated from the restrictions of the past. They preferred to paint realistic landscapes and scenes of everyday life rather than the traditional religious or historical themes. Such revolutionary talk must have amazed Degas, who had been following the conventional routes until then.

Degas' stay in Florence turned out to be longer than he had originally planned. His Aunt Laura was called away from her home when she received word that her father, Edgar's grandfather, was ill. When René-Hilaire Degas died on August 31, 1858, Laura prolonged her stay in Naples to attend to the funeral arrangements and to the settlement of the large estate her father had left.

Meanwhile, Degas made preparatory drawings for a large family portrait. Even after Laura returned to Florence from Naples, Degas found that the painting went far more slowly than he had anticipated. His father was growing increasingly impatient for Edgar's return to Paris, but he was pacified when Edgar sent home some samples of the work he had been doing. "I am very satisfied," replied his father, "and I can tell you that you have taken an immense step forward in art. Your drawing is strong, your color is right. . . . My dear Edgar, you no longer have reason to torment yourself. You are on an excellent track. . . . You have a beautiful destiny before you. Don't become discouraged; don't fuss and fret."

But fuss and fret is exactly what Degas continued to do. He made oil sketches, drawings, pastel studies of the Bellelli family, visualizing a painting six feet high by eight feet wide. Finally he realized that it would be impossible to paint such a large canvas in the confines of his aunt's furnished house. Announcing that he was returning to Paris, Edgar asked his father to find a studio for him where he could finish the great painting he had been working on for months.

It's uncertain exactly when Edgar finished the Bellelli family portrait. In fact, the painting disappeared from sight until the canvas was discovered many years after the artist's death, rolled up in a corner of his dusty studio. Degas never mentioned the portrait in his diary after he returned to Paris. He never discussed it with his friends, never showed it to anyone, and never submitted it for exhibition.

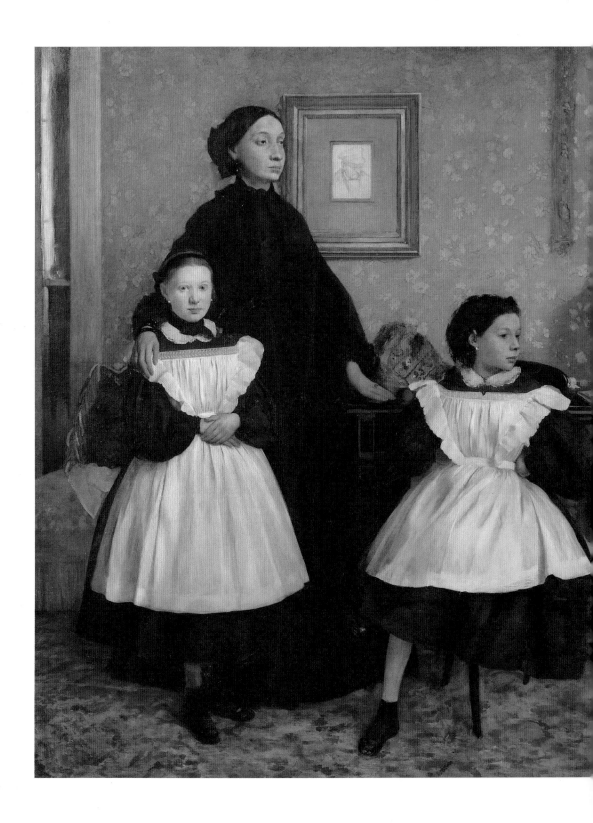

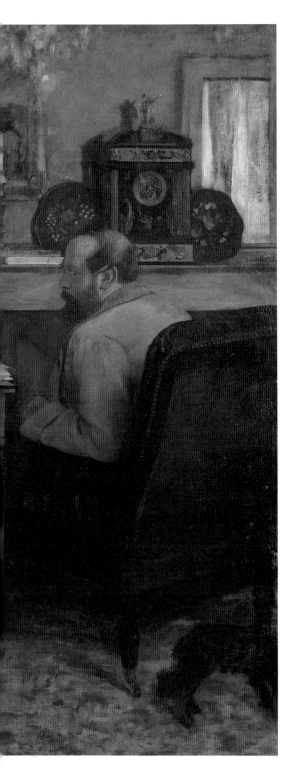

It's altogether possible that the painting was embarrassing to the family, for the Bellellis Degas painted were not exactly a happy family.

Although it was not a painting Degas seemed to prize, *The Bellelli Family* demonstrates the growing power of the artist's talent for composition, for drawing, and, most of all, for revealing the psychological tensions that lie beneath the surface. After two years and eight months in Italy, young Monsieur Degas, at age twenty-five, returned to Paris, well on his way to becoming a mature artist.

THE BELLELLI FAMILY. *1858-67.*
Degas' sensitive group portrait describes
a sad family: his Aunt Laura, who is
pregnant, looks grim and distant, while her
husband is glaring impatiently at her over his
shoulder. The marriage had been arranged by
Laura's father, whose portrait hangs on the
wall, and Degas must have known
that the union was unhappy.

THE OBSERVER

During the many months Degas had spent studying in Italy, Paris had been feverish with activity. Degas sensed this as soon as he returned. A major renovation of the city had begun several years earlier after the president of the French Republic, Louis-Napoleon, had suddenly declared that he was restoring the empire originally established by his uncle Napoleon I, and that he would be its new emperor. Emperor Napoleon III, as he called himself, was determined to make the Second Empire of France the greatest power in the world, and he appointed Baron Georges-Eugène Haussmann to be the architect in charge of transforming Paris into a grand capital.

Haussmann created a whole new plan for Paris, replacing narrow, winding streets with spacious, tree-lined boulevards and public squares that could be more easily defended by the military if the empire were ever under attack. Degas could see that in many sections of the city shabby old buildings had been torn down and were now being replaced by palatial theaters, hotels, department stores, and apartment buildings. He could experience how inviting it was to stroll the large new avenues and to rest his feet at a sidewalk café and watch the passersby or join in conversation with friends.

This was a visible transformation that had taken place while Degas was off in

Italy. Other signs of activity may have been less visible, but were definitely in the air. There seemed to be a lot more money around, and Parisians were spending it lavishly: on fashionable clothes, on horse races in the countryside, on the spectacles at the opera and ballet, on evenings at the cafés, and on art. In fact, art was becoming such big business that for the first time there were critics who specialized in writing on the subject; there were merchants who specialized in selling art; and there was an exhibition, the official Salon, that attracted hundreds of thousands of viewers every year.

The Salon was huge: more than 2,000 paintings and sculptures—selected by a jury from nearly 10,000 submissions—went on display in the enormous exhibition hall called the Palais de l'Industrie. Being selected for the exhibition was critical for an artist's career, but the process of selection was hopelessly haphazard. For two weeks, the Salon jury would review several hundred paintings every day; the paintings were laid out on the first-floor rooms of the exhibition hall, the largest canvases on the floor, the smaller ones propped up against the walls. Forty portly judges crowded around these paintings, talking all at once until the chairman of the committee demanded silence by ringing a bell. A vote was taken to accept or reject a painting, and they would move on to the next, repeating the noisy process. With so much at stake, and such general chaos, the selection of a painting for the exhibition depended more on chance and connections than it did on talent.

Even after a painting was selected for the Salon, where would it hang? Attracting notice was crucial because many important critics and potential buyers came to see the new work on display. Some walls contained five full rows of paintings hung from floor to ceiling, and every artist knew that a painting could be destroyed or enhanced by its position on the wall.

This highly competitive exhibition was controlled by a small group of artists elected to the ruling dynasty of the art world, the Academy of Fine Arts. The Academy set the artistic standards, approving only historical and religious subjects, pleasing pictures about everyday life, and paintings that told a story. A landscape or still-life painting might be accepted, but only if painted in dark

colors according to classical traditions. Originality was not encouraged.

Degas kept himself aloof from these fierce competitions in the art world. When he returned from Italy, he lived at home and worked in the studio his father had rented for him. He concentrated on finishing *The Bellelli Family* and experimented with other subjects as well. For all his hard work, he ignored the business side of being an artist: he did not even submit anything to the Salon, nor did he sell or exhibit any of his pictures. In just a short while his studio became cluttered with piles of finished and unfinished paintings. Where was he headed?

Degas' family was growing concerned. Soon Edgar would be thirty years old with nothing very tangible to show for his efforts. "What is fermenting in that head is frightening," his brother René remarked. "For my part, I believe—I am even convinced—that he has not only some talent but even some genius. Will he, however, express what he feels? *That is the question.*"

Jean-Auguste-Dominique Ingres.
VALPINÇON BATHER. *1808.*
The champion of Classicism, Ingres did not portray any form of suffering in his work, insisting that all artists should express an ideal world, meticulously created and beautifully drawn, just as the ancient Greek and Roman artists had done.

Degas went on his solitary way, but he was certainly aware of the stormy debates about art thundering all around him. One major debate had begun years before between two prominent French painters, Jean-Auguste-Dominique Ingres and Eugène Delacroix. The haughty Ingres, one of the most distinguished

members of the Academy, favored Classicism, arguing that artists must paint an ideal world, serene and pure. Correct drawing, he maintained, was the most important quality in all art and a beautifully drawn line was more critical to good art than all the colors on the palette. You had only to look at his paintings to see these ideas put into practice: his elegant historical scenes and icy portraits of royalty and wealthy patrons were meticulous in detail.

Eugène Delacroix, on the other hand, was the champion of Romanticism. He

Eugène Delacroix. LIBERTY LEADING THE PEOPLE. *1830.*
The champion of Romanticism, Dèlacroix rejected Ingres' ideas, arguing that emotional expression in any form was essential to good painting, and that color and action were the lifeblood of art.

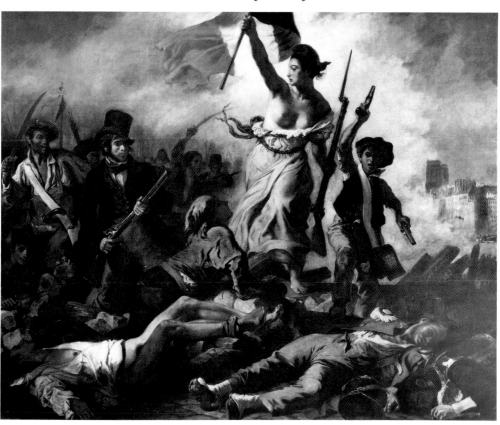

argued that expressing emotional freedom was more vital than freezing an ideal world in paint, that ugliness and suffering were crucial to great art. Like Ingres, Delacroix also painted scenes from history, but his paintings were explosive and turbulent. A battle scene, for example, displayed violent, twisting bodies propelled in every direction, with stormy skies raging overhead.

Degas remained open-minded about this debate. He admired both Delacroix and Ingres, though in his work he tended to follow Ingres' Classicism more closely than Delacroix's Romanticism.

By the time Degas returned from Italy, Ingres and Delacroix were old men. To the younger generation of artists, the old Academician Ingres had become a symbol of everything that was associated with tradition. At the cafés the heated debates continued long into the night: should an artist follow the traditional tenets of the Academy because they were correct or because this was the only way to succeed?

The more radical of the young artists tended to follow Delacroix. Why is it necessary to idealize your subjects, they asked. It is more important to record the facts as you see them before your eyes, objectively and dispassionately, without expressing sentiment or inventing imaginary details. "Show me an angel and I will paint it," scoffed the artist Gustave Courbet, who called himself a Realist.

The younger generation of artists would soon find a leader in an unexpected quarter. Edouard Manet was an independent young artist who came from a wealthy family, like Degas, and worked in a studio in the Batignolles section of Paris, snobbishly avoiding the cafés on the other side of town, where the bohemian artists tended to congregate. At first, Manet's career showed real promise: two of his paintings were accepted in the highly competitive Salon of 1861. Both received good reviews, and his charming picture of a Spanish guitar player even won an Honorable Mention.

But at the next Salon in 1863, the jury rejected all his submissions. Manet was not the only surprising rejection that year, however, and so many complaints were registered that Napoleon III finally agreed to permit a separate exhibition for the rejected artists, a *Salon des Refusés*. As it turned out, Edouard Manet was the scandal

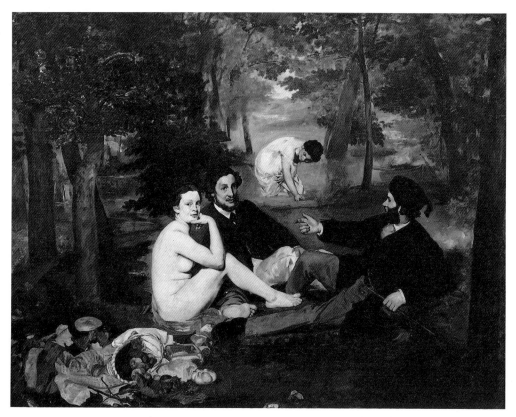

Edouard Manet. LUNCHEON ON THE GRASS. *1863.*
Manet shocked the public with this painting of a rather strange picnic in the park.

of this exhibition because of his large canvas portraying a picnic in a park, with a naked woman in the company of two clothed men. Called *Le Déjeuner sur l'Herbe* (*Luncheon on the Grass*), this picture shocked just about everyone who saw it. "Immodest," cried the emperor. "This vulgar enigma is either a young man's idea of a joke," one critic remarked, "or a festering sore, unworthy of comment."

Manet was suddenly drawn into the center of the storm, becoming an unwilling leader of the debate on behalf of change. In fact, he wasn't arguing for anything terribly revolutionary. He stood with Ingres, who had said, "Our task is not to invent, but to continue." No, Manet didn't want to throw out all he had learned from his masters; he simply wanted to extend his knowledge, to carry it

into uncharted territory. "Monsieur Manet," wrote one sympathetic critic, "has merely tried to be himself and nobody else." He now urged other artists to explore their untraveled routes also, to paint what they discovered along the way, to retain in their paintings the thrill of seeing the world with fresh eyes.

Degas had been introduced to Manet two years before the scandal at the *Salon des Refusés*. Although Manet was pleased to meet a fellow artist from the same social set, cultivated and well attired in the respectable black suit, silk top hat, gloves, and cane, he assumed that they had little in common. In the first place, Degas, who was practically the same age as Manet, had never even submitted any work to the Salon. Nor had he declared where he stood in the debates about art. Instead, he seemed to be interested in doing boring historical paintings that only went unexhibited anyway.

In spite of Manet's reservations, Degas was drawn to this dapper, stylish man-

SCENE OF WAR IN THE MIDDLE AGES. *About 1863.*
While the fierce debates about new directions in art raged around him, Degas painted this large historical scene which was accepted by the tradition-bound Salon in 1865.

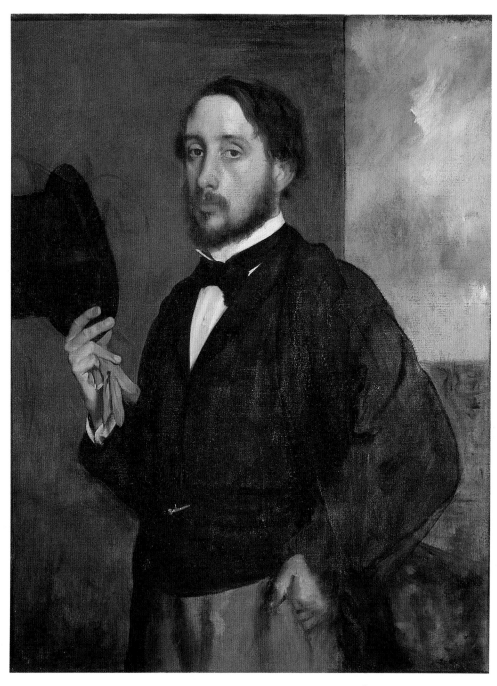

SELF-PORTRAIT: DEGAS LIFTING HIS HAT. *About 1863.*
*In contrast to his earlier portrayals, this self-portrait (his last) expresses a more
self-confident man, dignified and proud.*

about-town, and they became good friends. The association was good for Degas. In 1865 he finally submitted a painting to the Salon and it was accepted. The picture was a large historical scene—a far cry from another provocative nude by Manet, *Olympia*, hanging in a nearby room—but at least Degas was showing his work to a public audience. The same year he painted a self-portrait that suggested a man of much greater confidence and optimism. And that year he moved out of his family home to live on his own in a studio located in Montmartre, a neighborhood where he would live the rest of his life. From that point on, he never did another historical painting or self-portrait.

Although Degas was disappointed that his first painting in the Salon failed to attract notice, he continued to submit to the Salon for the next five years. No longer painting historical scenes, he entered portraits instead, as well as a steeplechase scene and a picture based on a ballet being performed at the time. Each year at the Salon he faced the same disappointment: no one seemed to notice his work. He decided finally that his paintings were too subtle to attract attention in the noisy atmosphere of the crowded exhibition halls and that the Salon was insensitive to the hanging of all artwork. In an effort to improve the situation, he wrote a letter to the *Paris Journal* with specific recommendations for how to display the pictures, suggesting that the exhibitors have some say in where and how their works were hung. But his letter went unnoticed and after 1870 Degas gave up on the Salon altogether.

The debonair Manet introduced Degas to his wide circle of friends, many of whom had moved to the Batignolles section of Paris near Montmartre, where Degas lived. For quite some time artists and writers had been coming in the evening to the Café Guerbois, a neighborhood café, decorated in the typical Parisian style with gilded mirrors and marble-top tables, where the waiters wore white aprons and black jackets. The Batignolles group, as these artists were called, included a wide variety of personalities. There was Camille Pissarro, kindly and generous; Paul Cézanne, who was often sullen and withdrawn; Auguste Renoir, whose personality was as sunny as his paintings; and the morose Claude Monet,

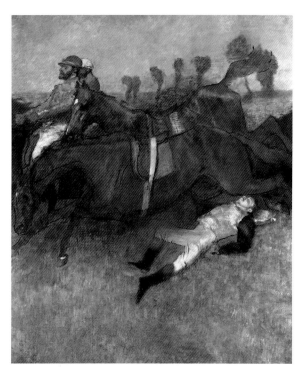

THE STEEPLECHASE. *1866.*

Using his brother Achille as a model for the fallen jockey, Degas made this canvas very large to attract attention at the Salon, but no one seemed to notice it. He soon became fed up with the Salon and refused to submit any more paintings.

who was always broke. Edouard Manet was generally the center of attention. Witty and self-assured, he often stirred the conversation into a boisterous exchange of ideas. Because Degas tended to be hot-tempered, he restricted his conversational contributions to a few carefully chosen words, and soon developed a reputation for his sharp and cutting remarks.

The Café Guerbois was not the only place where artists and writers regularly congregated. On Thursday evenings, Manet's mother invited her son's friends. Writers and artists would also meet frequently at the home of Berthe Morisot, an aspiring young female artist who shared their views. If not there, they might find a gathering at the home of Alfred Stevens, Nina de Callias, or Madame Lejosne, all friends sympathetic to the cause of change in art.

As a result of these encounters with experimental writers and artists, Degas' subject matter began to change. Like Manet, he was drawn to scenes of everyday life. Putting aside the classics, he began to read books by contemporary writers, particularly struck by the words of the author Pierre-Joseph Proudhon who wrote: "To paint men in the sincerity of their natures and their habits, in their work, in the accomplishment of their civic and domestic functions, with their

present-day appearance, above all without pose; to surprise them, so to speak . . . such would seem to me to be the true point of departure for modern art."

The subjects that attracted Degas' eye were the activities being enjoyed by the Parisians of the Second Empire: the racetrack, the musical soirees his father organized every week, the opera, and the ballet. To portray these subjects, however, he did not follow the practice recommended by the landscape painters Monet, Pissarro, and others he had come to know at the Café Guerbois. They insisted that art should be not only contemporary, but spontaneous as well. Now that you could keep oil colors fresh in tubes, which were newly invented, why paint in the studio when you could work right on the spot? The only way to really capture what was before your eyes, they argued, was to paint directly from life. This notion was appalling to Degas.

For all their personal differences, Degas and Manet turned out to have much in common artistically. While Degas tended to be controlled and methodical and Manet more spontaneous, they both agreed that it was better to train the memory than to work from life. Working from memory, Degas said, "you reproduce only what has struck you, what is essential; in that way your memories

LORENZO PAGANS AND AUGUSTE DE GAS. *About 1871. Degas' father, a gifted amateur musician, organized small concerts at his home on Monday evenings to which Edgar would go regularly.*

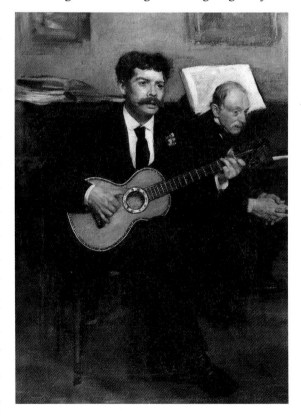

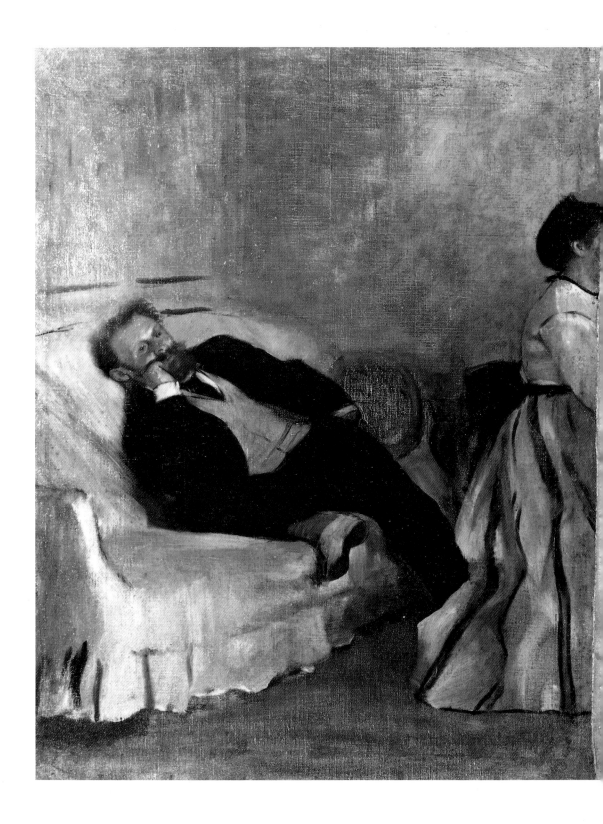

and your imagination are liberated from the tyranny that nature holds over them."

Besides, Degas liked to work in solitude, distant from his subject and from other artists. These landscapists were tromping out into the countryside in groups like a bunch of hikers. "Don't tell me about those fellows cluttering the fields with their easels," he scoffed. "I'd like to have a tyrant's authority to order the police to shoot down every one of them . . . the stupid fools, crouching out there over their stupid shields of white canvas."

Although Degas' subject matter was now concerned with modern life, his methods more closely resembled those used by artists for centuries. As he developed a painting he would consult a drawing from one of his notebooks, then refer to another of his sketchbooks, until he methodically assembled all the parts into a cohesive composition. This was Degas' realism: to paint what he saw around him, but to do it from a distance. For his entire life, Degas remained an observer, keen and sensitive, but always removed. Being distant from his subjects suited his personality.

MONSIEUR AND MADAME
EDOUARD MANET. *About 1868.*
Degas gave this portrait as a gift to his friend Manet,
but he became furious when he discovered that Manet had
slashed off the right side of the canvas, eliminating the piano
and half of Mrs. Manet. Degas complained, "A man who touches a
painting should be deported." He stalked off with the painting and
attached a new strip to the canvas with the intention
of repairing it, which he never did.

Chapter Three

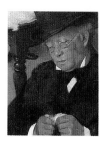

An Empire Collapses

In the summer of 1870, Napoleon III found himself suddenly drawn into a disagreement with Prussia, France's neighbor on the east (now part of Germany). He foolishly declared war on Prussia, mobilizing his unprepared French army for combat. The artists of the Batignolles group scattered in many directions when the war broke out. Monet and Pissarro took refuge in London; Cézanne fled to his family home in the south of France; Renoir joined a regiment. Degas—past the legal age for military service—remained in Paris.

Throughout the summer, French troops were slaughtered in one battle after another and Napoleon III was taken prisoner as the Prussian army began to advance westward toward the city of Paris. The Parisians, opposed to the war in the first place, declared an end to the empire and formed a new government that mounted a defense of the city against the approaching Prussian forces.

Seeing their city in real danger, Parisians quickly volunteered to serve in the National Guard. Degas was one of them. As the Prussian troops began to surround Paris, the National Guard volunteers stationed themselves in the old fortifications that encircled the city in preparation for combat. Rather than subject the troops to battle, however, the Prussians decided to wait it out, assuming it would take only about six weeks to starve the Parisians into surrender.

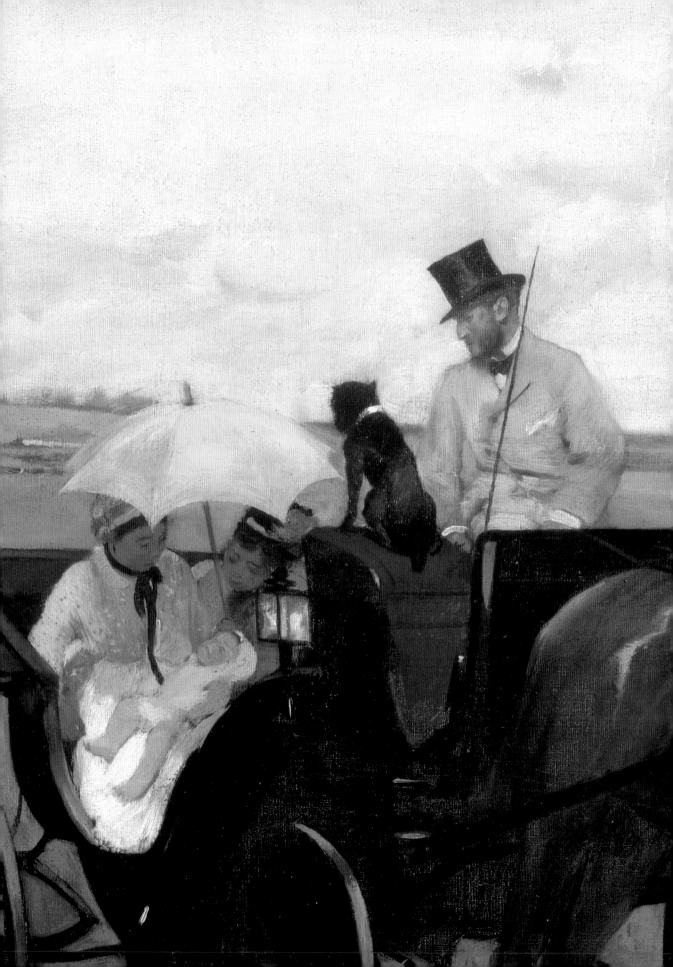

Degas took up his post at a fortification located on the opposite side of Paris from where he lived. Here he waited for the Prussians to attack. The mild autumn weather changed into one of the coldest winters in Parisian history, and food began to run out, just as the Prussian enemy had anticipated. Parisians grew desperate, eating cats, dogs, and rats when they could no longer find donkey or horse meat. When the gas supply was exhausted, people chopped down trees along the streets and public squares and tore down fences on construction sites, salvaging any wood scraps they could find for fuel to heat their homes. At the end of January 1871, the city finally surrendered.

While the new government of France negotiated a peace settlement with Prussia, Degas rested in the country at the home of his friend Paul Valpinçon. There he slept, ate well, and painted. It would have been an ideal recovery period if not for the impaired vision in his right eye caused by a chronic infection. He bought a pair of blue-tinted glasses, but they reduced only the glare without eliminating the blind spot in his eye. "I have just had and still have a spot of weakness and trouble in my eyes . . ." he wrote to a friend, "and it made me lose nearly three weeks, being unable to read or work or go out much, trembling all the time for fear of remaining like that." From then on, this fear of blindness was always with him.

While Degas was resting in the country, Parisians were up in arms. Humiliated by their defeat to the Prussians and outraged at the terms of peace the new national government had negotiated, the citizen army of Paris decided to take matters into their own hands. They elected their own city government, which they called "the Commune of Paris," completely repudiating the national government and the peace treaty it had negotiated. The Commune was brutally suppressed by the national troops that marched into Paris. In just eight days at least 20,000 Communards died in slaughter and executions. This enraged Degas until he heard how the Communards had turned into savages as they defended the city, burning buildings and shooting down hostages.

Although Degas did not witness the events of the Bloody Week of May, he was overwhelmed by the reports he heard when he returned to Paris a few days

later. He admired the Parisians for refusing to accept the peace treaty with Prussia, but he felt a blind loyalty to the French military that had suppressed the Communards. From that point on, Degas became a fervent patriot. It's ironic that the wordly Edgar Degas would develop into a conservative Frenchman, who wept over stories of military valor and national honor. Years later this narrow-minded patriotic fervor would cost him most of his friendships.

After the war, Degas was getting a good response to the new series of ballet pictures he was painting, but he felt restless. His eyesight worried him; he was bored by the talk of France's economic depression that dominated the conversations at the Guerbois every evening; he needed a change of scenery. Remembering how

CARRIAGE AT THE RACES. *1869.*
Degas frequently visited his friend Paul Valpinçon and took one occasion
to paint Mr. and Mrs. Valpinçon, a nurse holding their son, Henri, as well
as the family bulldog.

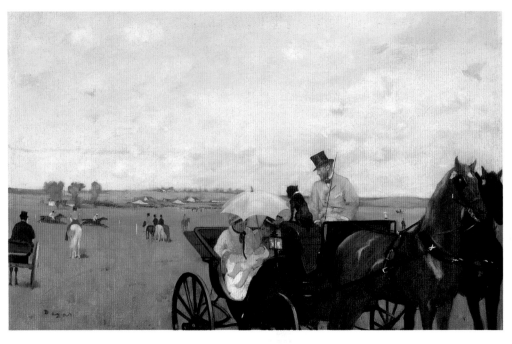

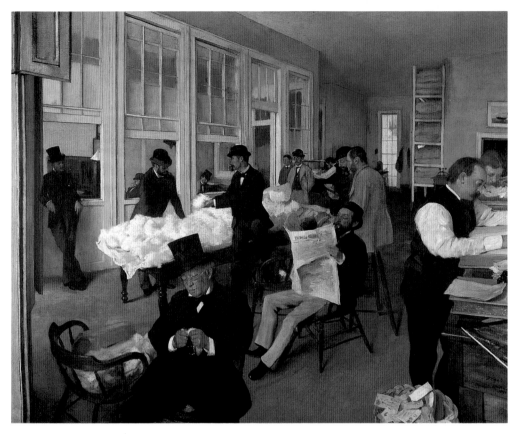

PORTRAITS IN AN OFFICE (NEW ORLEANS). *1873.*

*Degas' most ambitious painting from his visit to America was a work that included
his grandfather (seated in the foreground), his brother Achille (standing at the left), and
his brother René (seated with a newspaper).*

much he had enjoyed his American relatives when they came to stay in Paris nine
years before, Degas decided to visit them in New Orleans. Besides, Degas had
always been curious about the land of his mother. And the timing couldn't be bet-
ter: his brother René—who had married his American cousin Estelle—was in
Paris on business and would be returning to his home in New Orleans.

In October of 1872 the two brothers caught a ship in England and arrived in
New York ten days later. From New York they traveled for four days by train, an

experience Edgar found delightful. "In the train," he wrote to a friend, "you lie down at night in a proper apple pie bed. The carriage, which is as long as at least two carriages in France, is transformed into a dormitory . . . and then you can walk all around your own coach and the whole train, and stand on the platform, which is immensely restful and diverting."

Degas' family in New Orleans lived together in a mansion, seventeen people in all, including René and Estelle and their three children, as well as Edgar's younger brother, Achille, who worked with René in a wine-importing business. "What a good thing a family is," Degas wrote wistfully, as he observed the comings and goings around him. For his cousin (and sister-in-law) Estelle, he felt a particular empathy because she was incurably blind. "She accepts her blindness in the most extraordinary way, with almost no need for help when she is at home. She remembers the rooms and the positions of the furniture . . . and there is no hope," he said sadly. Was he fearful of the same thing happening to him?

Avoiding the painful glare of the bright Louisiana sunlight, Degas painted a number of family portraits. "Everything attracts me here. I look at everything," he said at first, but he soon grew restless. "Novelty captivates you and then bores you," he wrote longingly to a friend back home. "One does nothing here. It lies in the climate. Nothing but cotton. One lives for cotton and from cotton." This trip showed him that the deepest and most long-lasting inspiration came from what was familiar. "One loves and gives art only to the things to which one is accustomed. New things capture your fancy and bore you by turns." After five months in New Orleans he was ready to go home.

Once he returned to Paris, Degas finished a large painting of his grandfather and two brothers in a New Orleans cotton office, then returned to his own surroundings, inspired more than ever by the familiar Parisian subjects. "I want nothing but my own little corner where I shall dig assiduously. Art does not expand, it repeats itself. All your life you remain with arms extended, mouth open, in order to assimilate what is happening, what is around you and alive."

Edgar Degas had come home for good.

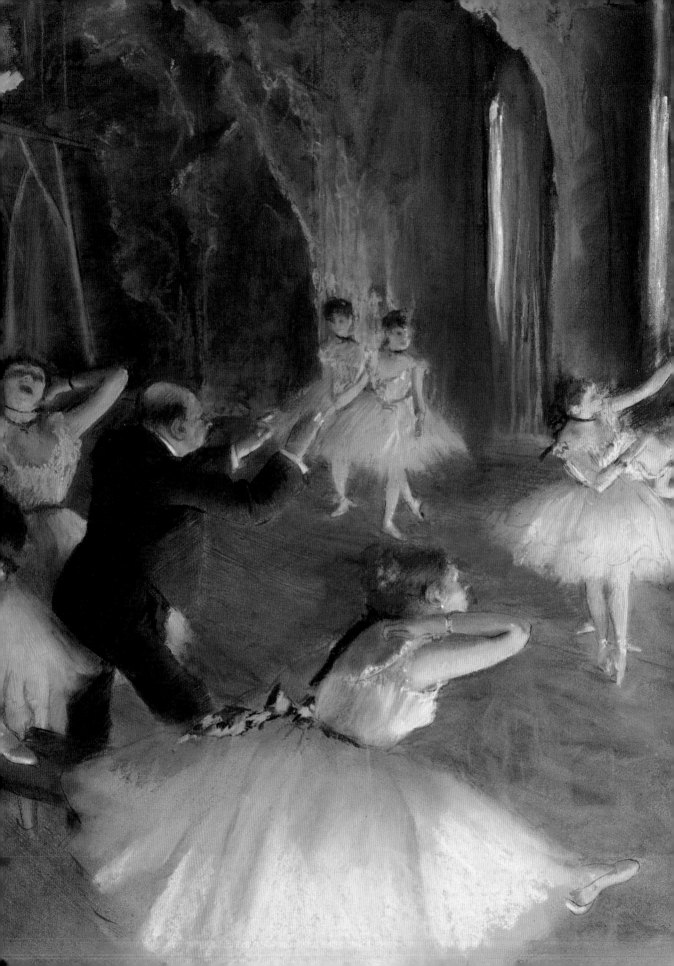

Chapter Four

THE INDEPENDENT

As Degas was approaching his fortieth birthday in 1874, he reached a turning point in his professional and personal life. In February of that year his father died suddenly during a trip to Italy. The death of Auguste Degas represented a great loss to Edgar in more ways than one. He always knew that his father had little liking for the banking business, but he had no idea that the family bank had fallen into such disarray. Although the war had created an economic depression, it was primarily his father's poor management that threatened to put the bank under. Auguste Degas had sold off assets and had borrowed money from another bank in order to lend Edgar's brother René 40,000 francs for starting up the wine-importing business in New Orleans. René was unable to pay back his debt without borrowing even more money. Edgar soon decided that the only way to save the family's business (and honorable name) was for him to take responsibility for the financial burden, a debt that took more than twenty years to pay off. For the first time in his life, Edgar Degas was forced to sell his paintings.

The loss of his father and these unexpected financial worries came at a time when Degas was already preoccupied with other matters: a special exhibition of the Batignolles artists and their friends, scheduled to open on April 15. The idea for an independent art exhibition had been proposed by Claude Monet the year

before. He felt that matters had gone from bad to worse for him and his friends. Just at the time when their work was taking off in so many interesting and unusual directions, commercial opportunities were drying up. There seemed to be no one left at the Academy of Fine Arts to champion their cause (Delacroix had died ten years earlier), which meant that the narrow-minded Salon jury was rejecting all their paintings. Meanwhile, their most important dealer, Paul Durand-Ruel, was feeling the effects of the economic depression and was not buying their work. The time had come to meet this urgent situation with an alternative plan.

Why would Degas be interested in the idea of participating in an independent exhibition with Monet and his friends? He no longer sent work to the Salon anyway, but even when he did, his work had always been accepted by the jury. He was lucky, perhaps, but his paintings sold well, especially in London, and even in these difficult economic times. So why would he agree to join Monet when he was so unsympathetic with the landscape painter's ideas about art?

As it turned out, Degas not only agreed to participate in the exhibition, he eventually became a leader of the group. For one thing, he shared their commitment to realism. In their work, they all aimed to record what they saw before them, including the defects and blemishes. Even the landscapist Monet, with whom Degas differed on almost everything else, studied nature with the precision of a scientist, analyzing how natural light actually altered the colors of objects from one hour to the next. Degas, the observer, shared this obsession with the real world and he was convinced the time had come to organize a French realist movement with an exhibition that would be every bit as official as the Salon itself.

For Degas, an independent exhibition also presented a legitimate alternative to the jury system. Only the artists themselves should determine what and how their work should be displayed. He despised the phoniness of the Salon, which was controlled by old cronies who favored their friends over artistic talent. And, finally, an independent exhibition would permit Degas to exhibit a number of paintings all at once. At last they would be hung favorably in a more intimate atmosphere, and they could be seen by prospective buyers, an appealing opportunity for an artist now faced with financial worries.

During the winter of 1873 the charter members held a meeting, a group that included Edgar Degas, Claude Monet, Auguste Renoir, Alfred Sisley, Berthe Morisot, Camille Pissarro, and five others. (Edouard Manet refused to participate, insisting that the official Salon was the only way to achieve lasting recognition.) At this exuberant gathering, they agreed to call themselves *La Société Anonyme des Artistes, Peintres, Sculpteurs, Graveurs* (the Independent Society of Artists, Painters, Sculptors, and Engravers). They also decided on the location of the exhibit: in the studio that had just been vacated by the photographer Nadar, located on the corner of one of the busiest streets in Paris.

As excited as he was about the event, Degas was also concerned that the exhibition not appear to be made up exclusively of those rejected by the Salon. He insisted that they invite some successful artists who had shown regularly at the Salon as well, so that the exhibition would not appear to be too provocative. The others reluctantly agreed, primarily because they understood that the greater the number of exhibitors the less money each would have to lay out for expenses.

Degas spent the next four months urging other artists to join the exhibition. By the time of the opening in April 1874 the catalog listed thirty exhibitors, and Degas could be pleased that the landscapists, whose work he disliked, were in the minority. A total of 165 works were displayed, including three ballet paintings, two laundry girls, one racing scene, and four drawings by Edgar Degas.

But the exhibition turned out to be a big disappointment. In four weeks only about 3,500 people came to Nadar's studio, a small number compared to the 450,000 attending the Salon the same season. And the ones who did come showed little respect. As they ambled arm in arm through the halls, they laughed aloud and jeered at the paintings. The reviewers were no more kind. "These artists appear to have declared war on beauty," spouted one. Another sarcastically called the exhibitors mere impressionists, a term that eventually stuck. The exhibitors themselves made no profit, even lost money, and decided to disband their society.

Degas, however, had reason to feel more optimistic. In spite of his association with the unpopular group of artists, Degas' work appealed to collectors. Seven of

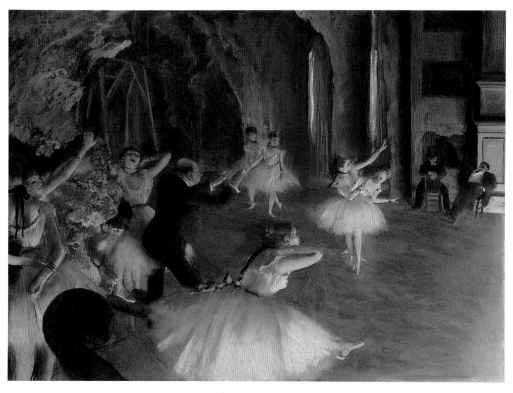

THE REHEARSAL ON THE STAGE. *1874.*

When Louisine Elder paid $100 for this pastel, she confessed years later,
"I scarcely knew how to appreciate it, or whether I liked it or not, for I believe it takes
special brain cells to understand Degas. There was nothing the matter with Mary
Cassatt's brain cells, however, and she left me in no doubt as to the desirability of the
purchase and I bought it on her advice."

his ten pictures in the exhibition were sold even before the catalog was printed. The ballet scenes Degas painted were attractive, and his drawing and painting techniques were meticulous, not at all like those messy canvases slapped together by Monet, Pissarro, or Renoir.

As his popularity in France began to grow, so did his appeal to English and American viewers. When the young American artist Mary Cassatt came to live in Paris, she was dazzled by a group of Degas' pastels hanging in the window of a

gallery on Boulevard Haussmann. "The first sight of Degas' pictures was the turning point in my artistic life!" she exclaimed. "I used to go and flatten my nose against that window and absorb all I could of his art. It changed my life." In 1875 Mary Cassatt introduced Degas' work to her wealthy American friend

DANCERS PRACTICING AT THE BARRE. *1876-77.*

Degas gave this painting to a friend as a replacement for another gift he had already taken home to rework. But Degas was not satisfied with this painting either. "Decidedly that watering can is idiotic," he would repeat. "I really must get rid of it."

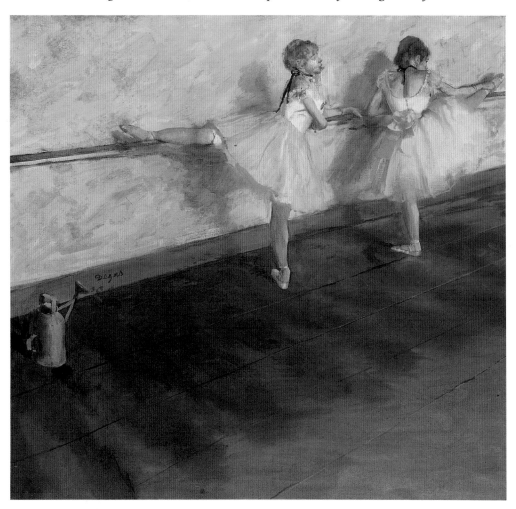

Louisine Elder, who promptly bought a pastel. This was the first acquisition for Louisine's important collection, and it was the first time any American had purchased a painting by a member of the French Impressionist group. (Louisine Elder, later becoming the wife of H. O. Havemeyer, went on to purchase many paintings of the contemporary French artists, and today the Havemeyer collection at the Metropolitan Museum of Art represents one of the finest collections of Impressionism in the United States.)

No matter how much he may have needed the income, Degas never liked selling his pictures. He thought commerce was demeaning, it's true, but the real fact is that he simply couldn't part with his work. He was constantly retouching, reworking, correcting. Even after signing a painting, he might scrape out entire passages and begin again rather than put it up for sale. He once persuaded a collector to give him back a painting for retouching. The collector never saw it again; Degas finally confessed that he'd completely destroyed the painting as he tried to improve it. Degas was known to buy back work from a gallery rather than see something sell that didn't meet his standards. "I would like to be rich enough to buy back all my pictures and destroy them by

PORTRAIT OF MARY CASSATT. *1884.*
The forty-year-long friendship of Degas and Cassatt was stormy. She hated this portrait of her holding Tarot cards, and she sold it immediately after Degas died.

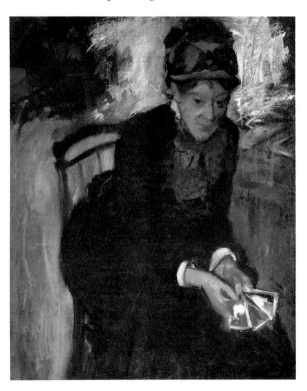

pushing my foot through the canvas," he once confided to a friend. Success did not make Degas any easier to deal with.

While Degas' career seemed to be taking off, the situation with his family was deteriorating. As the economic depression continued, the family finances fell from bad to worse. Then, in 1875, his brother Achille was involved in a scandal. The jealous husband of Achille's former mistress attacked him with a cane, and Achille defended himself by firing several pistol shots at his attacker. Both men were found guilty, and Achille was sentenced to six months in prison. Feeling more financial pressure than ever, Degas quickly joined up when the others began to talk of a second exhibition of their group at Durand-Ruel's gallery.

Manet again refused to join the group, and several of the original exhibitors pulled out, but charter members Degas, Monet, Renoir, Sisley, Pissarro, and Morisot recruited enough artists to bring the total number of exhibitors up to twenty. Eager to sell as much as possible, Degas submitted twenty-four pictures.

Reaction was mixed this time. Naturally there were some mean reviews, including one that singled out Degas: "Try to talk reason with Monsieur Degas, tell him that in art there are certain qualities called drawing, color, execution and control; he'll snort in your face and call you a reactionary." But in general the critics were milder in their attacks, and some were even favorable. One wrote that Degas was "a master of drawing, who has sought delicate lines and movements, and a strange new beauty." Degas waved off all the critics, good or bad, refusing to engage in all that "tittle tattle." To him all these words were nothing more than babble. "Beauty is a mystery," he maintained. "Among people who understand, words are not necessary. You say humph, he, ha, and everything has been said."

The others in the group were not so indifferent to the favorable notices they received. More confident of success this time, they immediately started to plan for their third exhibition in 1877. Degas was now convinced that the group was strong enough to stand on its own as an independent movement, and he felt that anyone who chose to exhibit with them must agree not to submit anything to the Salon as well. He urged his friends to attend a planning meeting, campaigning hard for his point: "A big question is to be debated: whether one can show at the

Salon and also with us. Very important!" Degas won his point: the group resolved that exhibitors could not show with them and at the Salon at the same time. But Degas lost on another point. Although Degas argued to the last that the term Impressionism was meaningless, especially in relation to his own work, the group voted to call the show an Exhibition of the Impressionists.

For the third exhibition only eighteen painters participated, but the number of works had increased to 230, many of which are regarded as masterpieces today. Degas submitted twenty-five paintings, pastels, and lithographs. Reviews were more positive, but sales were still not strong, even for Degas, who was feeling the pinch of the recession and the deteriorating situation with his family finances. Still more depressing to Degas was the news the following year that his brother René had further disgraced the family. Abandoning his blind wife, Estelle, and his six children, René had left New Orleans with another woman. Within a short while, four of the six children died, and Estelle's family abruptly severed all relations with the Degas family in France. Degas was stunned by the rupture with his sister-in-law Estelle, and it was many years before he would have anything to do with his brother René. Degas rarely talked about his problems with the family and resented any mention of it, but he was in pain: "You cannot imagine the troubles of every sort with which I am overwhelmed," he admitted to a friend as he was rushing to finish some pastels to earn his "bitch of a living."

To take his mind off his troubles, Degas focused on planning for the next Impressionists' exhibition. He was particularly anxious to recruit the talents of the American painter Mary Cassatt, whose work he had admired three years earlier at the Salon exhibition. Accompanied by a mutual friend, Joseph Tourny, Degas called at Cassatt's studio. She was flattered by the attentions of her favorite artist, and Degas was on his most charming behavior. When he invited her to renounce showing at the Salon and join the Impressionists instead, she gladly accepted. "I hated conventional art," she declared. "I began to live."

Degas' visit to Cassatt's studio launched a friendship that would last for forty years, an intense relationship that was continually interrupted by explosive quarrels and misunderstandings, but one that proved nourishing to both. He must

have felt at home with this stylish, outspoken, sharp-tongued American who reminded him of his own family in New Orleans and the American mother of his boyhood. Sharing similar ideas about art, they frequently encouraged each other to experiment with drawing, pastels, and printmaking. "I will not believe that a woman can draw so well," he said of Mary Cassatt, a compliment he paid to no other woman, not even to his good friend Berthe Morisot.

By now Degas had become fervent in his ambitions for a realist movement in art and an alternative to the Salon. He debated the issues in the late evening at the Café de la Nouvelle-Athènes, which had replaced the Café Guerbois as the favorite neighborhood hangout for artists and writers. Always contemptuous of public prizes, Degas was infuriated when Manet admitted one evening that he craved an award of honor. And he was dis-

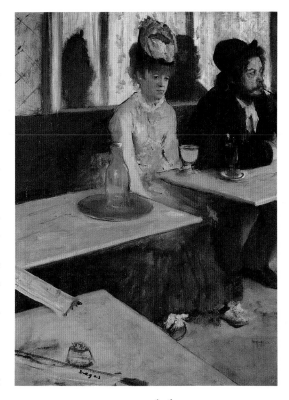

IN A CAFÉ (THE ABSINTHE DRINKER). *1875-76.*
At the Café de la Nouvelle-Athènes, where Degas gathered to meet his colleagues in the evenings, he painted two friends, the actress Ellen Andrée and the painter Marcellin Desboutin. About the work, which powerfully conveys sadness, the actress later said, "We look like a couple of idiots."

tressed to hear that Renoir and Monet were suffering such financial hardship that they felt compelled to submit to the Salon. But Degas continued to campaign hard for an independent exhibition in spite of the resistance he felt around him.

The independent artists continued to mount exhibitions for three more years,

each year with growing acceptance by the critics and public, but each year with growing antagonism against Degas. "He is indeed vexing," one of the group complained, "but you have to admit he has talent." Degas particularly irritated the members of the group with his insistence that outsiders be recruited to increase their numbers and to add importance to the exhibition. Mary Cassatt was one of their favorites, but Degas had introduced other artists to the group who were definite lightweights. And diplomacy was never one of Degas' strengths, after all. "Degas has caused disunity among us," complained the artist Gustave Caillebotte, who had exhibited with them several times. "He spends his time harping at the Nouvelle-Athènes, when he would be much better occupied in turning out a few more pictures. . . . He now cites practical necessities, but he doesn't allow the same for Renoir and Monet. Before his financial losses was he really any different from what he is today? Ask everyone who knew him then. No, this man has gone sour. He doesn't have the high rank his talent deserves, for which he bears the whole world a grudge, although he'll never admit it. . . . If Degas wants to join us, let him, but without all those people he drags along with him."

The kindly Camille Pissarro, one of the few remaining charter members, refused to "leave friends in the lurch" and supported Degas. "He's a terrible man, but

AFTER THE BATH. *1882-84.*
At the eighth and final exhibition of
the Impressionists, Degas exhibited a series of
nudes bathing which many people found
shocking and offensive.

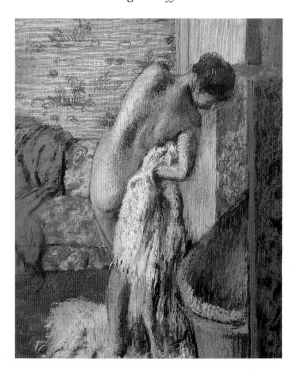

frank, upright, and loyal," Pissarro said. In protest, Caillebotte withdrew from the group and the exhibition proceeded without him. In the end, it was a mediocre show that attracted little notice. Degas himself had submitted only a half dozen works (mostly sketches) and a wax statuette of a little ballerina.

The group was now hopelessly divided into factions. So few of the original exhibitors remained that the notion of an independent movement seemed a lost cause. To restore vitality to the exhibition, it was mandatory that Renoir and Monet return in 1882. They agreed to accept, but only if the exhibitors were restricted to those of the original group. "The little clique has become a great club that opens its doors to the first-come dauber," Monet sneered. Renoir and Monet insisted they be allowed to submit to the Salon as well. Feeling betrayed and rejected, the proud Degas withdrew from the seventh exhibition. Out of loyalty to her friend, Cassatt withdrew as well. It would be two years before there was any discussion about another exhibition of the Independents.

As Degas approached his fiftieth birthday in 1884 he took stock of his situation. His reputation as an artist was growing and sales were now steady. He no longer lived in his studio, now able to afford a separate apartment and full-time housekeeper. He saw Cassatt almost daily, organized evenings at the opera with his friends, and regularly visited the Nouvelle-Athènes, although the atmosphere at the café was very different after the recent death of his friend Manet. All things considered, he was feeling more generous when Berthe Morisot approached him about rejoining the Independents for the next exhibition.

The eighth exhibition in 1886 turned out to be the last show of the Independents. Degas submitted a pastel of a woman trying on a hat at the milliner's (for which Mary Cassatt posed) and a series of pastels of nude women. But the real attention was focused on the enormous paintings of two younger artists, Georges Seurat and Paul Signac, painted with tiny dots of color in a technique called Pointillism. Now the public hissed at a new generation of painters, having finally accepted the artists whose work they had found so shocking at the first exhibition of the Impressionists twelve years before.

A chapter had ended.

Chapter Five

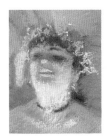

DEGAS' PARIS

From the time he painted his final historical subject in 1863, Degas dedicated himself exclusively to painting the everyday life he observed around him. Over the years, he worked and reworked the same themes—horse racing scenes, ballerinas, evening entertainments, working women, and women bathing— creating endless variations that demonstrated his extraordinary imagination and technical skills as an artist. Exploring these themes through his eyes means taking a journey back to France of the nineteenth century.

Degas was a Parisian through and through. Although he enjoyed traveling, Paris was the place he loved most, and life in Paris was his favorite subject. In fact, he lived sixty of his eighty-three years within an area of only a few square blocks in Paris, the neighborhood in and around Montmartre. There he frequented his favorite cafés, visited and entertained his friends, painted his ballerinas, laundresses, prostitutes, café entertainers, musicians, and bathers. While other artists rushed to the countryside, to unusual subject matter for inspiration, Degas found everything he desired in the familiar surroundings of his beloved Paris.

When Degas turned away from historical subjects, he decided to paint what he knew best, the scenes a man of his social class would see around him. First he

BEFORE THE RACE. *1884.*

*Degas would strive to make his paintings
seem spontaneous, as if he had captured a rapidly
passing moment, much the way a photographer
stops action with his camera.*

turned to the musical events he attended regularly, the informal concerts his father arranged every Monday evening, and the musicians playing at the Opéra nearby. Then he turned to the subject of horse racing.

Although horse racing had been very popular in England for many years, it was not until the nineteenth century that France took a serious interest in the sport. During the Second Empire, horse racing became an especially fashionable social event. When Baron Haussmann was rebuilding all of Paris, Napoleon III instructed him to plan for Longchamps, the finest racetrack in the world, inside the Parisian park called the Bois de Bologne. The annual opening day at Longchamps ranked with both the opening night at the Opéra and the first day of the official Salon as the most glamorous event of the season. In fact, you were likely to see the same people at all three spectacles.

As a student, Degas had filled his notebooks with drawings of horses, mostly copies he had made of paintings by the Old Masters in Italy, but he had little direct experience with the animal except as a necessity for travel. He first became excited about racing as a subject for his work in 1861, when he went to the races and toured the breeding farms in northern France with his friend Paul Valpinçon. He was immediately struck by the movement of the animals, the colors of the jockeys' silks, and the gaiety and excitement of the spectators.

Degas was not particularly interested in the specific horses themselves, unlike

some other French artists of the day, or even in the sport of racing. To him the horse races simply gave him an opportunity to portray a great social occasion, to apply marvelous colors to canvas, and to explore the effects of light. There were several very famous horses at the time, but Degas never made any effort to depict them. His horses tended to resemble the ones he had seen in the paintings of the great artists of the past. He was also fascinated by the costumes worn by the jockeys at the races, but he invented their colors, never following the actual colors representing the owners.

Specific events and locations were of no consequence to Degas either. What did it matter which horse won or lost what race? Most of his paintings focus on the moment *before* the race anyway. The scene might be at the Longchamps racetrack, but a viewer would know that only from the title of the painting, because Degas would completely change the setting to suit his pictorial composition. He never painted these pictures on the spot, as Monet might have done. Instead, he worked in the studio from memory, models, sketches, and notes. If you notice a similarity in pose between a horse in one painting and a horse in another, it

ORCHESTRA OF THE OPÉRA.
About 1870.
Although Degas was a "realist," portraying actual scenes from the life around him in Paris, he always altered reality to suit his painting.
Here, for example, it was more important for his composition to place the bassoon in the foreground than to have the musicians seated where they would be normally.

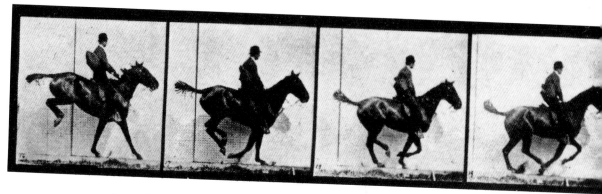

is no accident. Degas sometimes

made a tracing of a horse from his sketchbooks and used it in a number of different compositions, fitting together the pieces as if he were assembling a jigsaw puzzle. He was, above all, a picture-maker, not a racing fan.

For Degas the real action took place not on the racetrack but in his studio. When asked why he didn't prefer to paint his racing scenes from life, Degas took down a small wooden horse from a shelf in his studio and replied, "When I come home from the racetrack, these are my models; how could you make real horses

(Above and Below) Eadweard Muybridge. HORSES IN MOVEMENT. *1887*
Muybridge set up a camera with an intricate release device to capture the stages
of movement of a mare named Sally Gardner as she galloped across a stage.
(Right) THE FALSE START. *1869-71.*
By analyzing Muybridge's photographs, Degas realized that he had been
mistaken in thinking that horses galloped with the legs outstretched. Future
paintings would correct this error.

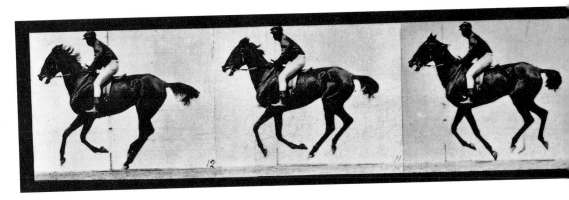

turn in the light the way you want?" The trick was to transform what he had actually seen and learned into something even more truthful, using whatever devices necessary. "Art is the same world as artifice; in other words, something deceitful. It must succeed in giving the impression of nature by false means, but it has to *look* true."

Degas made numerous paintings on the theme of horse racing throughout the 1860s; then he interrupted this work for several years as he concentrated on portraits, ballet scenes, laundresses, and activities at millinery shops. When he took up the subject of racing again in the

early 1880s, he explored a whole new range of ideas, incorporating his fascination with movement, photography, and Japanese art.

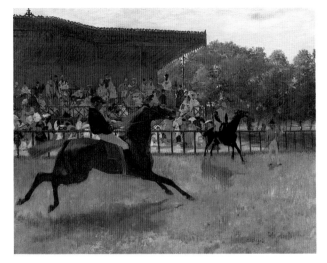

Degas had been troubled for quite some time by his lack of knowledge about horses. He admitted that he could only tell "the difference between a purebred and a half-bred," and that he "was quite familiar with the anatomy of the animal" from his studies of plaster casts, but he was aware that he understood little about the way horses moved. "I knew infinitely less about the subject,"

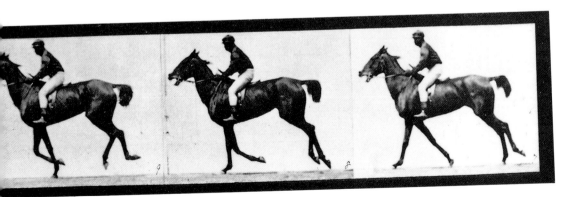

he confessed, "than a noncommissioned officer whose lengthy and attentive practice on horseback enables him to visualize the animals' reactions and reflexes, even when he's speaking about an absent horse." But how could he record what the naked eye was unable to see?

Eadweard Muybridge, a photographer working in California, provided the answer for Degas. Using an elaborate setup of cameras and tripping devices, Muybridge managed to record on camera the step-by-step sequence of a horse walking, trotting, cantering, and galloping. Muybridge's photographs exposed all the mistakes artists and sculptors had been making in their work. By studying these photographs closely, Degas discovered that horses did not fly through the air, galloping with all four legs outstretched the way he had depicted in his painting *The False Start*. The movement was actually much less graceful. All four feet were off the ground only when they were quite close together, not when they were stretched out. Taking what he had learned from Muybridge, Degas returned to racing pictures with passion. Now his paintings became studies in movement, rather than scenes of social occasions.

Muybridge had demonstrated how photographs could arrest action, making it possible for Degas to observe reality more closely. With photographs he observed, for example, that horses walk on their toes like ballerinas, which meant that Degas could apply what he learned to all movement. He even applied this new knowledge to sculpture, where he could study movement in three dimensions. "It is the movement of people and things that distracts and even consoles me," Degas said. "If the leaves of the trees did not move, how sad the trees would be and we, too."

By arresting movement in midair, photographs seemed more spontaneous than carefully posed paintings. Degas experimented with compositions, trying to make his pictures appear as if they were not composed at all, as if they were snapshots taken while the subjects were unaware. An unexpected portion of the composition might run right into the edge of the picture, cropped off much the way the image in a photograph might be. He even took many of his own photographs, experimenting with composition as well as light.

Just as Degas benefited from the innovations in photography, he was also inspired by the traditional prints being imported in great numbers from Japan. He was intrigued by the dramatic cropping of figures, the use of color and pattern, and the simplified shapes laid out in flat patterns. He noticed that the Japanese frequently silhouetted foreground objects, obscuring what lay behind, to give a sense of perspective. From the Japanese, Degas learned to place an unexpected object or figure in the foreground, slicing the picture vertically or dramatically throwing the composition off-center.

Degas was attracted to ballet for many of the same reasons he was drawn to horse racing. In fact, no other subject fascinated him for so long. He painted his

HORSES WITH JOCKEYS. *1885.*

From his study of photographs and Japanese prints, Degas began to compose his paintings even more dramatically than before, cropping off figures and objects and overlapping flat areas of color wherever doing so seemed to suit the composition.

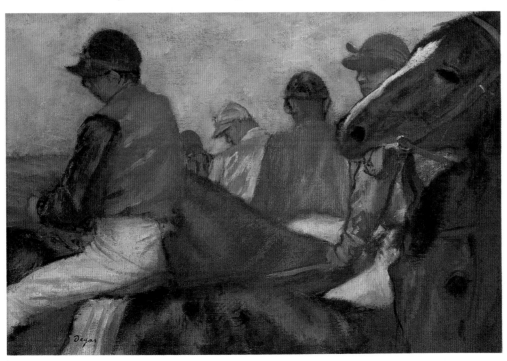

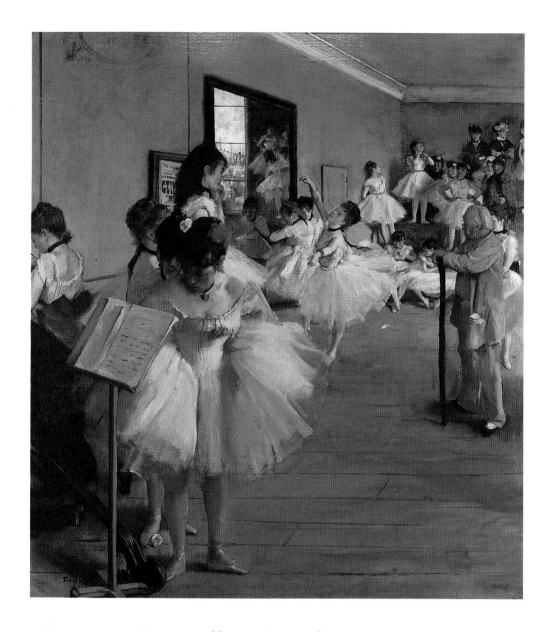

*Degas would often take a similar situation or
composition and rework it in every detail. Although these
two paintings, both called* THE DANCE CLASS *(above 1874
and at right 1875-76), seem nearly alike, Degas left very
little of his earlier painting when he revised the subject
in a new version.*

first ballet scene in 1866, and he continued to be inspired by the subject for the rest of his working life, creating about 1,500 ballet drawings, paintings, pastels, and sculptures. This is not so surprising when you consider that everything Degas considered important came together with ballet: his respect for the discipline and repetition required of all artists, his sympathy for working women, his interest in movement, his love of music and the theater, his curiosity about the French society in which he lived. Although others had painted ballet before Degas, and so many have imitated his work since, no other artist has ever brought such originality to the subject. The name of Edgar Degas has become synonymous with the art of ballet.

Just as he had been charmed by the costumes worn by the jockeys at the races, Degas was enchanted with the costumes of the ballerinas. The colors, the textures, the accessories delighted him, and he made notes and drawings of exactly how the ribbon on the skirt was tied or the way in which the lacy folds of the short, flaring skirt called a tutu fell from the waist. The theatrical stage lighting at the ballet appealed to Degas, and he made a note "to work a great deal at

evening effects, lamps, candles, etc. The fascinating thing is not to show the source of light, but the effect of light."

No matter how much he may have enjoyed the lights, color, and pageantry of the theatrical performance, Degas had a special feeling for what was happening behind the scenes. In fact, only a small portion of his pictures portray actual performances. He was far more focused on the dance class, the rehearsal studio, the

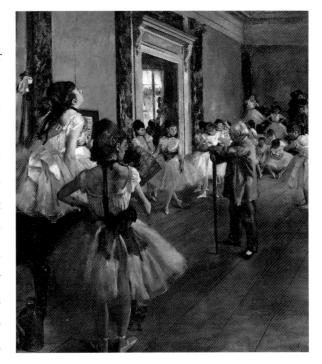

little events that sometimes occur backstage in the wings or down the corridors of the theater.

As with horse racing, when Degas depicted the ballet, he was not concerned with accurately recording a specific person, event, or location. A window or mirror, placed anywhere in the composition that suited him, might be the only recognizable detail from an actual theater or rehearsal room. Even the costumes were embellished by the artist's imagination. Just as he did with the racing pictures, Degas would repeat the same pose of a dancer in several pictures.

The ballet scene gave Degas an ideal opportunity to arrange colors and shapes, applying what he had learned from photography and from Japanese prints. He could manipulate the figures in his compositions in much the same way as the choreographer directed the ballerinas on the stage. His fascination with movement led him to study dancers in motion, something that no other artist before him had ever attempted.

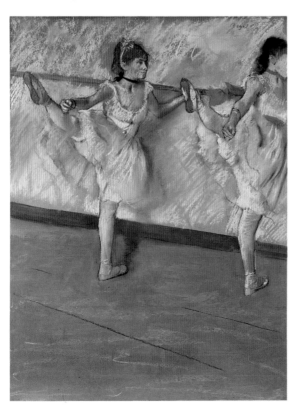

Most of all, ballet was a subject Degas could paint and repaint endlessly, always exploring new forms of expression. In this way Degas felt a particular empathy for the ballerinas who practiced their art with such discipline, repeating their movements again and again as they reached for perfection. Practice and repetition, Degas understood, required physical effort and concentration, whether you were a musician, dancer, laundress, or artist. Even the race horses were trained as specialists. He demonstrated this point

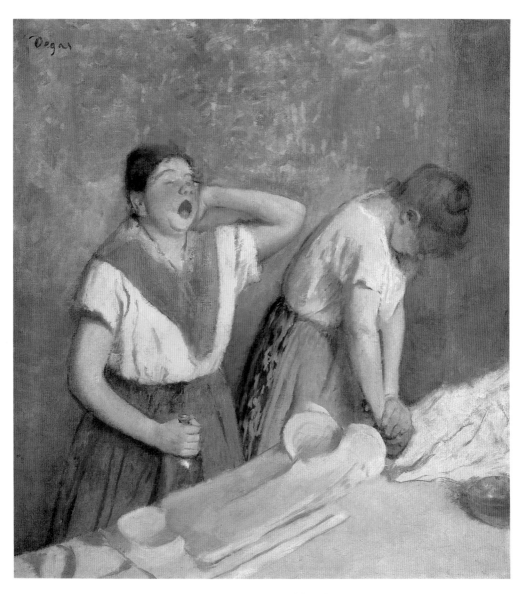

LAUNDRESSES. *1874-76.*

Degas depicted the women who did laundry to earn a living with the same compassion he painted ballerinas. They, too, were hardworking women.

DANCERS AT THE BARRE. *1877-79.*

The idea of repetition was very important to Degas. Only through practice, by repeating the same action over and over, was perfection obtainable. This idea applied to dancers, jockeys, musicians, and artists.

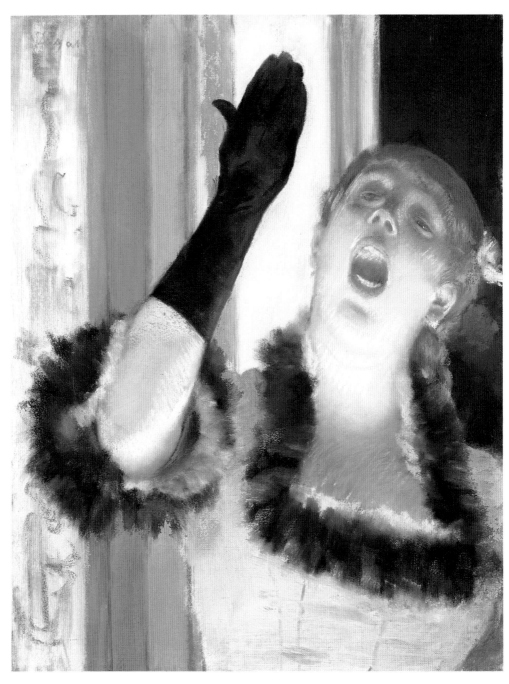

SINGER WITH A GLOVE. *1878*

Degas was fascinated by the particular glare of the footlights produced by the gaslight fixtures. Here, too, his exaggerated composition suggests a snapshot.

to friends by imitating precisely in pantomime the gesture of a laundress at the iron, a woman removing her gloves, a dancer at the barre. "The same thing must be done ten times, one hundred times over," stressed Degas. Repetition was the only way to get it right. "Nothing must resemble an accident," he repeated. "No art was ever less spontaneous than mine."

As an artist, Degas understood what was demanded of dancers, but his compassion for the ballerinas went even deeper. Ballerinas usually began their apprenticeship when they were seven or eight years old. At the age of ten, the more promising girls were given a small salary and permitted to study dance for the next eight or nine years with the hope of joining the company. There was nothing glamorous about these hard-working girls, whose only formal education was in the rehearsal studio. "When people talk of ballet dancers," Degas explained, "they imagine them covered with jewelry and lavishly maintained with a mansion, carriage and servants, just as it says in the storybooks. In reality more of them are poor girls doing a very demanding job and finding it very difficult to make ends meet."

Degas painted these young dancers as he saw them, exhausted from their hard work. He observed a girl scratching her back, another yawning from fatigue or gazing off in boredom. To the critics accustomed to seeing sentimental portraits of famous ballerinas, Degas' portrayal

THE SONG OF THE DOG. *1876-77.*
At the Alcazar Café, Degas particularly enjoyed a performer called Thérésa, who made a specialty of a number called "The Song of the Dog." Here, the singer's hands mimic the paws of a dog.

63

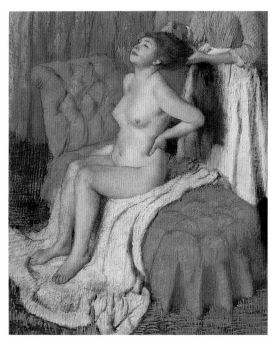

A WOMAN HAVING

HER HAIR COMBED. *1886-88.*
To get the gesture just right, Degas spent
hours combing the hair of his model before
he began to paint her.

(*Opposite*) THE TUB. *1885-86.*
By capturing a woman's private moments at the
bath, Degas conveyed in his painting the sense
that the viewer is peeking through a keyhole,
with the subject completely unaware.

was disturbing. To them, these girls were "arch, sly, vain, and ugly." As usual, Degas ignored the critics.

Degas seemed to sympathize with women struggling to make a living through physical effort, whether they were ballerinas, laundresses, singers, or even prostitutes. He loved to wander through Paris, even in the poor neighborhoods, his eyes wide open to every detail. "You go into these wretched-looking houses with great wide doors," he explained, "and you find bright rooms, meticulously clean. You can see them through the open doors from the hall. Everybody is lively; everybody is working. And these people have none of the servility of a merchant in his shop. Their society is delightful." Through the ground-floor windows of these apartment buildings, Degas could see into the famous laundry rooms of Paris, the baskets of wash and linens piled high, as the young ironers, bathed in sweat, pushed their heavy irons back and forth or stretched and yawned from fatigue. Degas recorded these scenes as he saw them.

Degas was also drawn to the women who worked as entertainers at the so-called café-concerts, which had become very popular with Parisians during the Second Empire. After a regulation restricting theatrical costumes had been lifted,

managers of indoor and outdoor cafés began to hire pretty singers in flashy costumes to perform nightly. At a café-concert you could sit at a table, smoke a cigarette (which you couldn't do in the regular theaters), buy an inexpensive drink, eat, chat with your friends, and enjoy some lively, if rather crude entertainment. Degas was fascinated by the illusions created by the gaslights and costumes and by the female entertainers dressed in sparkling colors, who belted out their songs to make themselves heard over the rowdy chatter of their audience. All this was magical for Degas. When a landscape painter questioned whether these scenes were suitable subjects for serious art, Degas responded, "For you, natural life is

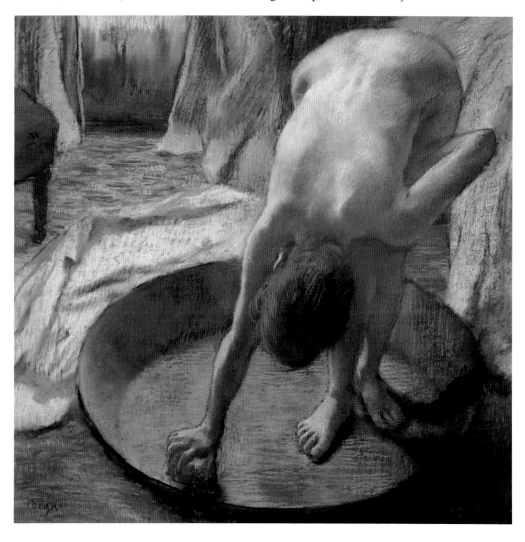

necessary; for me, artificial life."

Degas regarded even prostitutes as nothing more sensational than working women. The brothels of Paris were famous throughout Europe, an accepted institution in French life. A census taken during the Second Empire reported that there were more than 40,000 working prostitutes, many of whom were legally registered with the police. In a series of fifty prints depicting scenes from brothels, Degas portrayed these prostitutes as ordinary hardworking women, often amusing, down-to-earth, and honest.

There is nothing pornographic about any of Degas' nude subjects. At the final Impressionist exhibition in 1886, Degas displayed a series of seven pastels entitled: "Series of nudes of women bathing, washing, drying, rubbing down, combing their hair, or having it combed." He intended to present these nudes from an altogether new approach. "Until now," he explained, "the nude has always been represented in poses that presuppose an audience." Degas was no longer interested in conventionally composed pictures. In his racing and ballet paintings the scenes seem unposed, as if they were snapshots taken while the subject was unaware. Why not take the same approach with a truly private scene?

"My women are honest, simple folk," Degas remarked, "concerned with nothing beyond their physical condition. It's the human animal taking care of its body, a female cat licking herself." Degas set up tubs and basins in his studio and studied the models as they performed their natural ritual, portraying them "as if you were looking through a keyhole."

The subject itself was not unappealing. After all, bathing had become a more common practice since gas heating had made it possible to install separate bathrooms in modern Parisian homes, but these scenes were shocking nevertheless. Looking through a keyhole at a woman's most private activities seemed like a crude idea, especially since these bathtubs seemed to be located in bedrooms or dressing rooms, not in bathrooms. What kind of women were they? Degas might call these women "honest and simple," but to many they appeared vulgar and graceless, with their awkward poses that exaggerated their fat rumps and masses of hair. To the models who posed for him, Degas' bathers seemed bizarre. "Degas

WAITING. *1882*

*Very few of Degas' ballet paintings
actually portrayed a performance.
The artist was far more interested in
what took place behind the scenes.
He preferred to contrast the artificial life
on the stage with the tedious life of
the ballerina, a contrast dramatically
expressed here with the different
clothing worn by the two
seated females.*

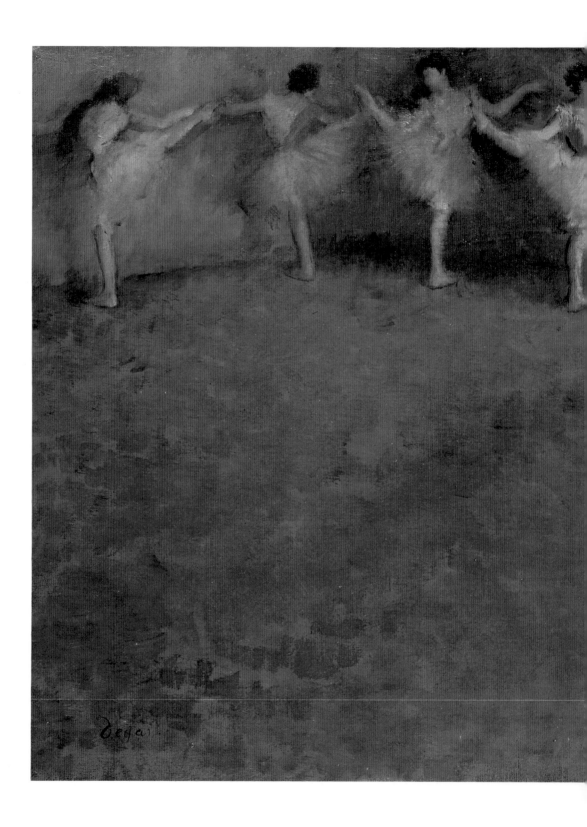

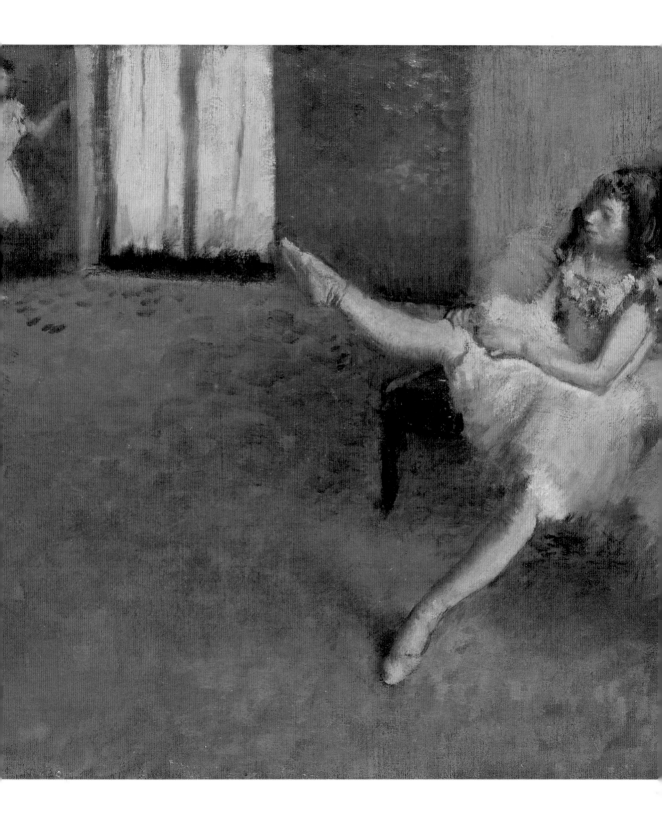

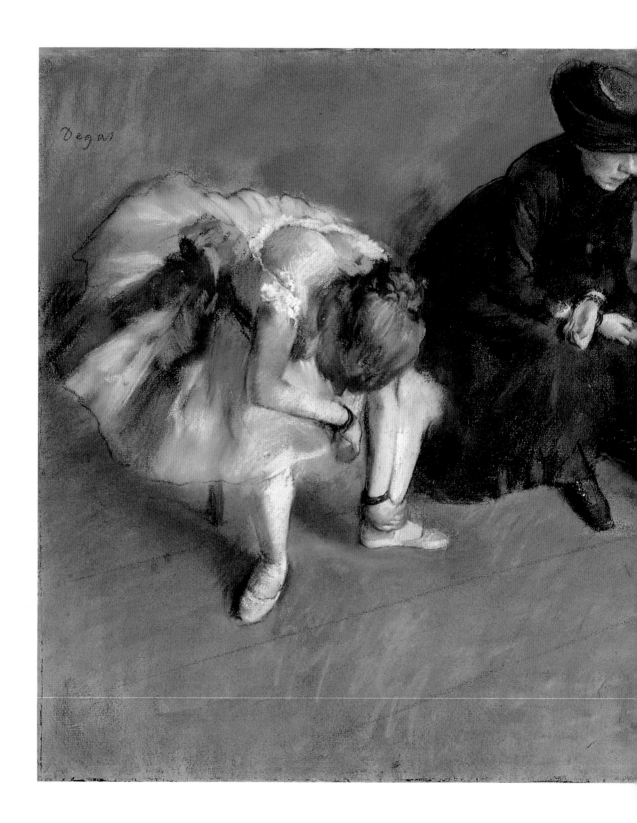

67

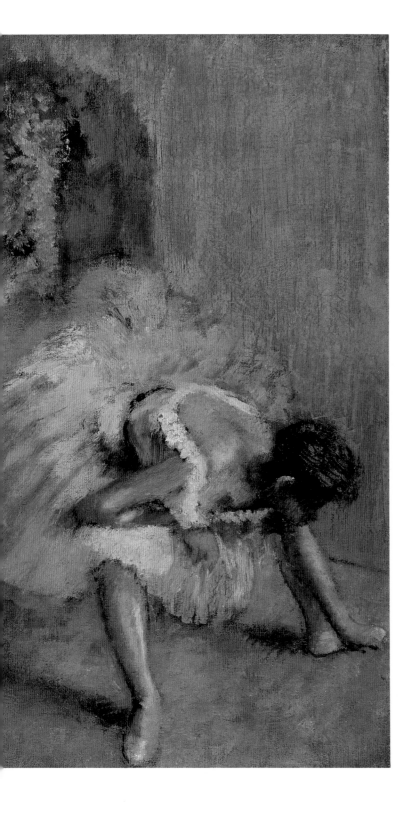

BEFORE THE BALLET. *1890-92.*
Although the life of the ballerina may seem glamorous on the surface, the ballerinas of Degas' paintings knew little luxury. The young girls who were admitted to the Corps de Ballet (the ballet company) worked long, hard hours for not much money and almost no recognition. Degas depicted them as they were: often exhausted from rehearsing in the mornings and performing at night, tired of having no money for new clothes or better living conditions, and restless to be doing other things.

BALLET DANCER IN HER
DRESSING ROOM. *1878-79.*

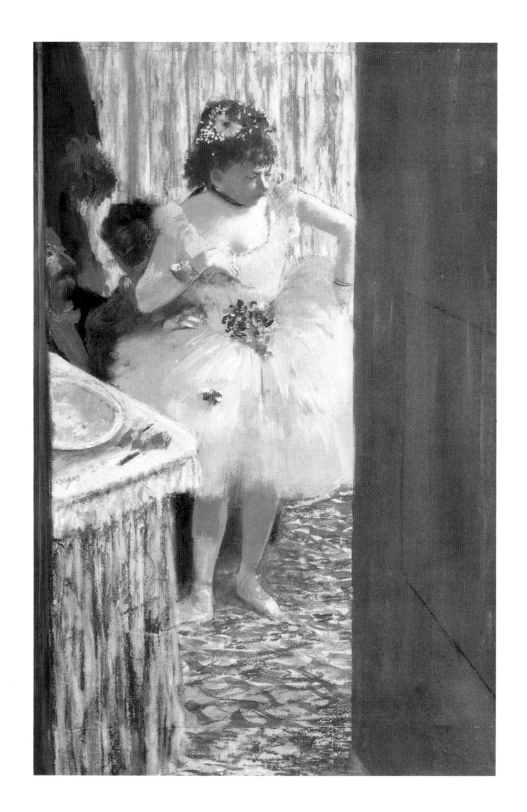

DANCER WITH BOUQUET. *1877-78*

As much as he might focus on the routine activities taking place behind the scenes, Degas also enjoyed ballet from the viewpoint of the audience. Like a choreographer, he staged the composition of his paintings with brightly costumed figures illuminated dramatically by artificial lighting.

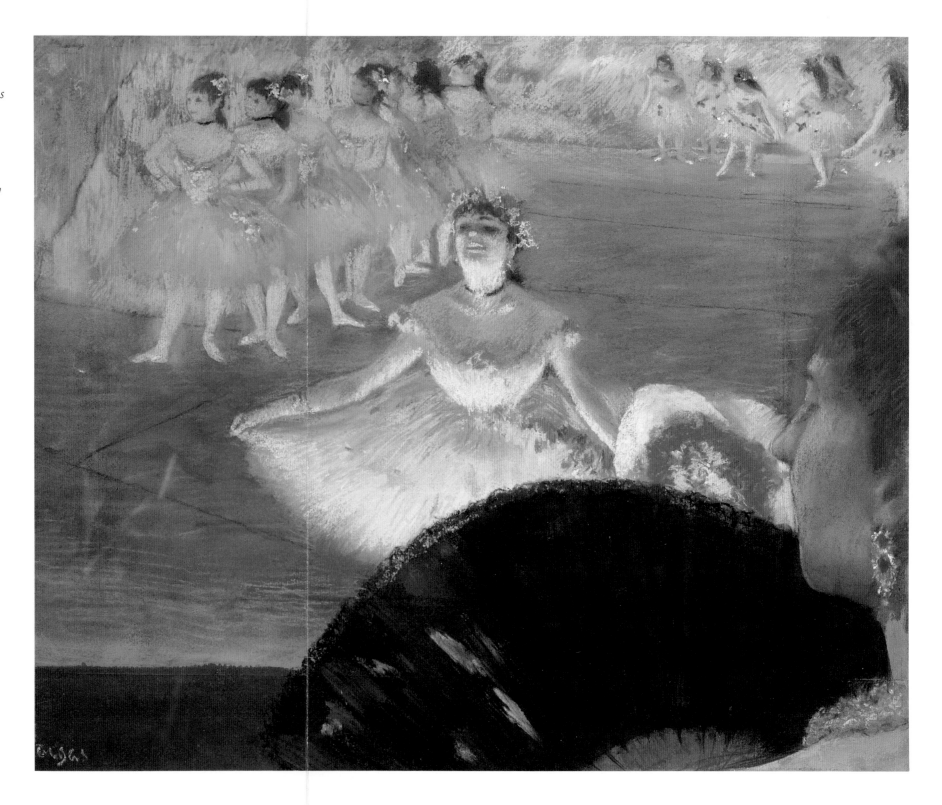

is an odd monsieur," remarked one of these models. "He spent the four hours of my posing session combing my hair." Another model reported, "Can you imagine what we pose for with Degas? Well, it's for females climbing into tubs and washing their rear ends."

Degas experimented with a variety of ways to depict his favorite subjects, and over the years he simplified his pictures. From ten or more dancers in his early paintings, Degas reduced the number to three or four at the most. He was like an inventor, always trying out different poses and compositions, tinkering with his tools and working methods, and constantly jotting in his notebook experiments worth trying. He studied the paintings and writings of the early artists whose work he so admired, learning everything he could about their painstaking techniques; then he adapted their methods to suit his own preferences. He studied everything he saw around him, borrowing, adapting, experimenting in what he called his "cuisine, the cookery of art."

For years Degas painted in oils, meticulously building up smooth layers of pigment on his canvas as the Old Masters of the fifteenth and sixteenth centuries had done—quite unlike Monet, who preferred to slap thick globs of oil paint directly onto the canvas. Because Degas was continually reworking his paintings, however, he was often frustrated by the fact that oil paint had to be scraped down and allowed to dry before it could be reworked. He also grew to dislike the glossy surface produced by oil paints. Seeking a mat, unshiny surface, Degas experimented with egg tempera, an ancient technique combining pigment with raw egg, but he abandoned this method when his paintings cracked. He also worked with gouache, an opaque watercolor. Eventually he returned to oil paints, trying out the newly invented synthetic colors, and experimenting with a technique called *peinture à l'essence* in which he soaked out the oil from the color by putting it on blotting paper first.

But it was pastel that offered Degas the alternative he was seeking. First introduced in the eighteenth century, pastel (which resembles colored chalk) had been used exclusively for drawing until Degas expanded its range with his innovative

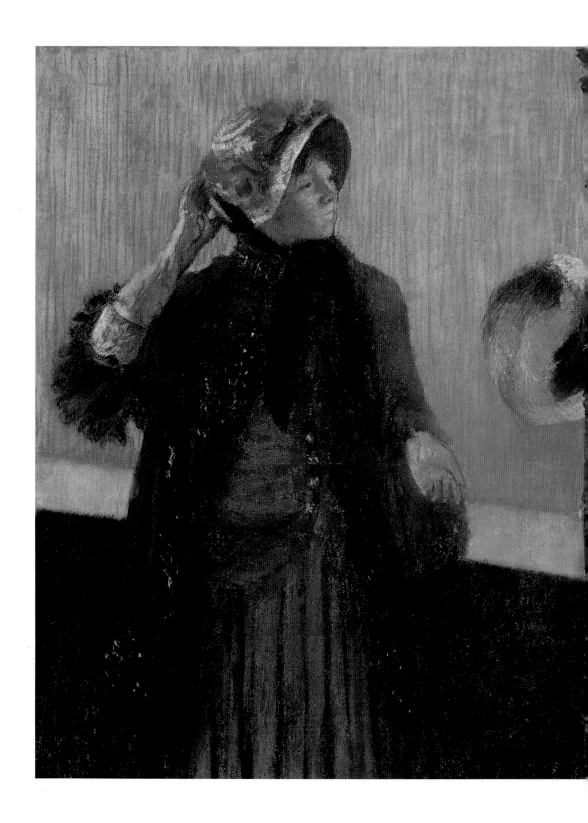

ways of handling it. Because pastels are very bright, they can be garish when handled by artists less versatile than Degas. With pastel, Degas was able to obtain the mat surfaces he preferred. He no longer needed to mix colors on the palette, as he did with oils, and he could achieve results instantly and rework easily. All these features made pastel the favorite medium of this impatient perfectionist, especially after the family's financial troubles, when he needed to make money more quickly. From the 1870s on, nearly eighty percent of his paintings were in pastel.

At first Degas simply drew with the pastel directly on paper, blending the colors by rubbing them with his finger or a paper tool shaped like a pencil. Then he began to build up the pastel in layers, as he had done with oil paints, allowing portions of each layer to peek through to the surface. To make the crumbly chalk adhere to the paper, he sprayed a specially prepared fixative onto each layer. Sometimes he would blow steam from a boiling kettle onto a fresh layer of pastel, turning the chalk into a paste that he could push around with the tip of his brush.

AT THE MILLINER'S. *1882.*

Mary Cassatt allowed Degas to accompany her to fashionable millinery shops so that he could observe women trying on hats. She also sat for him several times, particularly when he could not get his professional models to pose as he wanted and hold a particular facial expression.

At other times he would grind up the pastel into a powder, add water, and apply this "soup" to the paper with a brush. An entry in his notebook reminded him to try "mixtures of water-soluble colors with glycerine and soda to make a pastel soup." He found pastel so versatile that he combined it with other media as well, with gouache and tempera, applying it to pen-and-ink drawings, to prints, and to oils on all different kinds of paper.

Degas' natural curiosity about techniques led him to explore the possibilities of printmaking, a process in which images are created from printing plates.

Degas learned about making images from painters who worked centuries before him, but he also used modern technology, such as photography. This photograph, believed to be by him, shows a ballet pose that he repeated in several paintings.

Printmaking was attractive to Degas because he could retouch and rework a plate indefinitely, which suited his temperament. He and Mary Cassatt explored the possibilities of printmaking together and became so excited about their experiments that they talked about publishing a magazine to provide a forum for all artists wanting to share their ideas on the subject.

First Degas and Cassatt tried etching, a process in which an image is drawn on a coated metal plate. The lines are burned in with acid, and then the plate is inked and the surface wiped clean, so that the ink remains only in the etched lines. Finally the plate is put through a press and the ink transferred to a sheet of paper, creating the final image.

Degas also became interested in

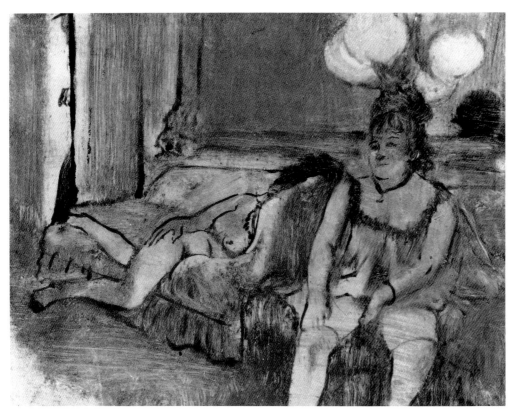

RESTING. *1876-77.*

Degas regarded prostitutes as simple, hard-working women, no less sympathetic than the ballerinas, laundresses, and entertainers he painted so frequently.

monotypes, in which he drew an image directly on a smooth metal plate with a stiff brush and oil paint or greasy printer's ink. Next he pressed a sheet of absorbent paper onto the plate to create one clear impression, and maybe one or two more faint ones, to which he added oil or pastel.

Constantly exploring new forms of expression, Degas turned to sculpture as well. At the sixth Impressionist exhibition in 1881 Degas showed a strange wax sculpture called *The Little Dancer of Fourteen Years.* Degas dressed the figure in real slippers, stockings, and leotard, smeared a thin coating of hot wax over this clothing, then added real hair, a gauze tutu, and a ribbon. This startling and unusual

piece was the only sculpture Degas ever exhibited during his lifetime, but he continued to work in wax privately, repeating in three dimensions the ideas he had always explored in two. After his death, about 150 little pieces of sculptured wax were discovered scattered around his cluttered studio. The pieces that could be salvaged were cast in bronze, rescuing for the future what the artist had never bothered to preserve himself.

For Degas, the studio was a retreat from society, a private sanctuary to which he admitted very few people. He particularly resented the invasion of his privacy by idle curiosity-seekers. "My God! People crowding around our pictures, why? Do they crowd into a chemist's laboratory? A chemist works in peace." After ringing the downstairs bell, even his good friends might have to wait a long time until Degas checked them out and decided whether or not to let them upstairs. A rare visitor to the studio marveled

DANCER LOOKING AT THE
SOLE OF HER RIGHT FOOT. *1900-10.*
In the privacy of his studio, Degas created
numerous sculptures that were not discovered
until after his death.
THE LITTLE DANCER
OF FOURTEEN YEARS. *1879-81.*
After making a sculpture in wax, Degas dressed the
figure in real slippers, stockings, leotard, human hair,
a gauze tutu, and ribbon.

80

at the room cluttered with bathtubs, cellos, bathrobes, a piano, broken-down chairs, printing presses, bottles, pencils, bits of pastel, etching needles, wax figurines, and a whole variety of odds and ends that could be useful one day. "The labor of the artist is of a very old-fashioned kind," one visitor observed, "working in his own room, following his own homemade methods, living in untidy intimacy with his tools, his eyes intent on what is in his mind, blind to his surroundings; using broken pots, kitchenware, any old castoff that comes in handy. Degas is a survivor of a disappearing species."

It was in his studio, distant from the subject, distant from the emotional conflicts that tormented him, that Degas conjured up images from his imagination like a magician. "A picture is an artificial work," he repeated, "something apart from nature that demands as much cunning, astuteness, and vice as the perpetration of a crime."

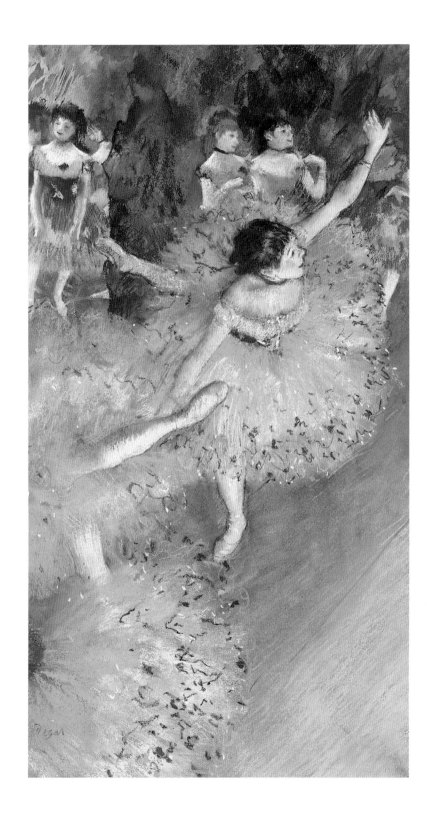

Chapter Six

Famous and Unknown

B y the time Degas turned sixty years old, he had become a celebrity. His paintings of ballerinas, racehorses, café-concerts, laundresses, and bathers were being purchased at increasingly higher prices by wealthy French and foreign collectors. He had become an idol to the next generation of artists and writers. A group of young admirers competed for his attentions, eagerly writing down their every conversation with the aging eccentric genius. "Degas now occupies the most enviable position an artist can attain," one of these young men remarked. "He is always the subject of conversation when artists meet, and if the highest honor is to obtain the admiration of your fellow workers, then honor has been bestowed on Degas as it has been bestowed upon none other."

Degas continued to produce new work every day, his fierce appetite for experiment constantly drawing him into new avenues of expression. He became fascinated by photography, and he began to write sonnets, achieving remarkable

GREEN DANCER. *1880.*

Anticipating the excitement just before the spectacle begins: this is the moment Degas preferred to portray in his ballet and horse racing scenes.

results in both. He indulged in his passion for travel, and for the first time departed from the human figure as subject to create some very unusual landscapes.

Throughout his long and productive career Degas nurtured his few close friendships. According to his good friend Halévy, "Degas never tired of a friendship or a hatred, nor of an admiration, joke or grievance." Another friend remarked that "this seemingly bearish man was capable on occasions of mellowing to the point of showing affection . . . for friendship was a cult with him.

Every evening Degas changed from his work clothes and went out with old friends, to the theater or a café, or to a dinner party, where he was considered a desirable addition because he was an excellent conversationalist, always witty and provocative. Occasionally Degas instructed his housekeeper, Zoé, to prepare one of her terrible meals for guests. Degas even reconciled with his disgraced brother René, with whom he had not exchanged a word for fifteen years.

Degas had achieved in his lifetime what most people long for: he was a gifted artist whose talents were rewarded, and he was surrounded by good friends. But as the years passed, Degas actually became more bitter. His fame, for example, was a burden. He had absolutely no patience with dilettantes and curiosity seekers who sought his company, and any form of publicity disgusted him. "These people want to make me think I have *arrived*," he sneered. "*Arrived*, what does that mean? *Arrived* at what? . . . They have to have a finger in every pie. They have the chess board of the fine arts on their table and we artists are their pawns. They move this pawn here, that pawn there. But I'm not a pawn, and I don't want to be moved!" More than anything, Degas wanted simply "to be famous and unknown."

With the years, as his untrimmed beard grew and his hair turned white, Degas became more eccentric. Even his walk became worthy of note: "At the racetrack or in the street," a friend observed, "he advanced leaning on his cane, with his belly somewhat out in front and his legs following in the indolent manner of a duck, but this odd way of walking was rapid enough to make the flaps of his caped cloak fly around his shoulders."

Degas developed the reputation for being a crank. He complained about peo-

ple who arrived late and people who called him "sir." He hated central heating, big lamp shades, and women on the bus who wore large bonnets fastened with long hatpins that stuck out. He actually seemed to enjoy playing the role of the curmudgeon. "What's this I hear?" he asked a friend one evening. "What's this I

LANDSCAPE. *1892.*

For a short period of time in his later years, Degas painted a few unusual landscapes, though he never worked on the spot. He despised outdoor painting and would say, "If I were in the government I would have a brigade of policemen assigned to keeping an eye on people who paint landscapes outdoors. Oh, I wouldn't want anyone killed. I'd be satisfied with just a little buckshot to begin with."

hear? Are you going around saying I'm not wicked, that people have made a mistake concerning me? If you take that away from me, what will I have left?" Being ornery was his method of getting people to leave him alone. "He valued his reputation for spitefulness and rudeness," a friend commented. "In his eyes it had the advantage of keeping bores at a distance and providing him with an aura that amused him."

Eventually, however, Degas' prejudices and fierce temper cost him nearly all his valued friendships. The event that caused this rupture was the Dreyfus Affair. Ever since the terrible defeat of France in the Franco-Prussian War of 1870, many French people—including Degas—distrusted their German neighbors and were nervous about spies. Alfred Dreyfus, an obscure captain in the French Army, was arrested on suspicion of handing over information to the Germans. Given the facts of the case, it appears that Dreyfus was arrested primarily because he was Jewish, rather than because there was any conclusive evidence against him.

When the news of Dreyfus' arrest made the headlines in Degas' favorite newspaper—the notoriously anti-Semitic *La Libre Parole*—the incident suddenly erupted into a heated controversy that divided the country into two camps, shattering old friendships and breaking up families. Most intelligent French people recognized that Dreyfus was innocent and regarded the charges against him as altogether unjust. In the other camp, however, the strong prejudice against the new population of poor Jewish refugees recently emigrated from Eastern Europe was now directed at Alfred Dreyfus, and the obscure army officer became a symbol of a dangerous foreign enemy.

Ever since the Franco-Prussian War, Degas had been an ardent patriot, fervently supporting a strong French military, and he was convinced that the Jewish captain was guilty, in spite of the facts that attested to Dreyfus' innocence. Degas became a fanatic on the subject, turning against everyone, including nearly all his friends, who disagreed with him. "Degas is very unhappy," noted the son of his Jewish friend Ludovic Halévy, "He has become a passionate believer in anti-Semitism." Before long, most of Degas' old friends avoided him. It was years before Mary Cassatt resumed her association with Degas, and his old boyhood

friend Ludovic Halévy never saw him again.

Working less and less intensely in the studio because of his failing eyesight, Degas became preoccupied with other activities, such as collecting antique canes, and lace-trimmed handkerchiefs from Normandy. Of all his obsessions, none was greater than collecting art. He combed the galleries and attended auctions, driven by an insatiable passion to own the works of all the artists he admired. "I buy, I buy, I cannot stop myself," he sighed. By the time of his death he had amassed an enormous collection of important paintings, prints, sculptures, even Persian carpets. He was so compelled by this drive to collect that he would bid feverishly at auctions even when his poor vision meant he was unable to see what he was buying. "Is it beautiful?" he asked a friend after he had purchased a painting that he had never seen.

Zoé Closier was Degas' loyal housekeeper for years. Although she was known to be a poor cook, Zoé prepared meals for Degas every evening and for his guests when he was feeling sociable enough to entertain. Here she is seen with Degas, sometime just before 1900, in a photograph that may have been taken by his brother René.

As Degas' eyesight became worse, he grew more reclusive. In the privacy of his studio he turned to sculpture in clay or wax, responding in his fingertips to what his eyes failed to see.

When Degas was told that the apartment where he had lived for many years was being demolished, the seventy-eight-year-old artist moved to a small place nearby, but never bothered to unpack. Bumping into an old friend on one of his daily outings, he said, "You see, my legs are good. I walk well, but since I moved, I no longer work. It's odd. I haven't put anything in order. Everything is there,

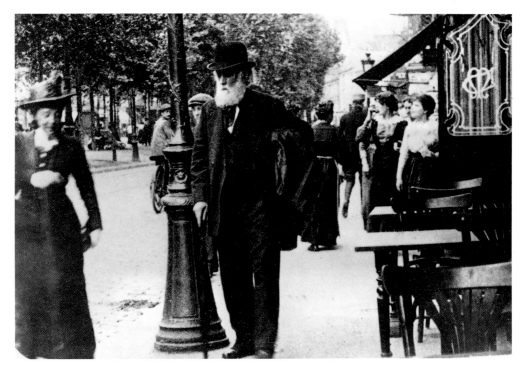

Degas walks along the Boulevard de Clichy in 1914. Degas' daily outings became an obsession. Every afternoon he put on his bowler hat and cape, took his cane in hand, and went on long walks through the neighborhood, always alone, or rode back and forth on top decks of the streetcars.

leaning against the walls. I don't care. I let everything go. It's amazing how indifferent you get in old age."

Mary Cassatt, unable to sustain her grudge against this nearly blind old man, made arrangements for Degas' niece to care for him until his death on September 27, 1917. "We buried him on Saturday," Cassatt recalled, "in beautiful sunshine, a little crowd of friends and admirers, all very quiet and peaceful."

When his friends and family entered Degas' apartment to clear it out, they were amazed at what they discovered. The rooms were piled high with his unsold paintings and early works he had repurchased. Crumbling fragments of wax sculptures were scattered throughout the studio. On the walls, in the closets, lean-

ing against the walls were hundreds of items he had bought for his collection. A fortune was made from the sale of all these artworks the following year. Degas, who was never satisfied with anything he painted or collected, raised enough from this sale to spare his heirs from poverty. For the last time, he had come to the rescue of his family.

In his final months, Degas permitted visitors to his dusty studio. At these times he seemed to withdraw into himself, preparing in his mind what was worth repeating to the guest. Then he would utter aloud his thoughts, phrasing the words carefully as if he knew they were being recorded for future generations. On one such occasion he complained about the art critics who had always annoyed him. "How simple it would be," he grumbled, "if they would only leave us in peace. They bore the public with our works, they bore us with their articles and fine phrases. They want to explain everything, always explaining. But you can't explain anything. Beauty, beauty is a mystery."

Hilaire-Germain-Edgar Degas, an artist who became virtually blind during his lifetime, visualized what the critics could not: "Art is not a matter of what you can see, but what you can make other people see."

By 1915, no longer able to work or care for himself, Degas withdrew into himself, seeing only a few people now and then, until his death in 1917.

LIST OF ILLUSTRATIONS

PAGE 51 (detail) and PAGES 73-74: *Dancer with Bouquet*. 1877–78. Pastel over monotype on paper, $15^{7}/_{8}$ x $19^{7}/_{8}$". Museum of Art, Rhode Island School of Design, Providence; Gift of Mrs. Murray S. Danforth

PAGE 53: *Orchestra of the Opéra*. c. 1870. Oil on canvas, $22^{1}/_{4}$ x $18^{1}/_{4}$". Musée d'Orsay, Paris

PAGE 54–55: Eadweard Muybridge. *Horses in Movement*. 1887. Collotype print, image $7^{1}/_{4}$ x $16^{1}/_{4}$". Philadelphia Museum of Art

PAGE 55: *The False Start*. 1869-71. Oil on panel, $12^{5}/_{8}$ x $15^{3}/_{4}$". Yale University Art Gallery, New Haven; John Hay Whitney, B. A. 1926, Hon. M. A. 1956 Collection

PAGE 57: *Horses with Jockeys*. 1885. Oil on canvas, $10^{3}/_{8}$ x $15^{11}/_{16}$". Yale University Art Gallery, New Haven; Gift of J. Watson Webb, B. A. 1907, and Electra Havemeyer Webb

PAGE 58: *The Dance Class*. 1874. Oil on canvas, 33 x $31^{3}/_{4}$". The Metropolitan Museum of Art, New York; Bequest of Mrs. Harry Payne Bingham, 1986

PAGE 59: *The Dance Class*. 1875–76. Oil on canvas, $33^{7}/_{16}$ x $29^{1}/_{2}$". Musée d'Orsay, Paris

PAGE 61: *The Laundresses*. 1874–76. Oil on canvas, 32 x 30". Private Collection

PAGE 62: *Singer with a Glove*. 1878. Pastel and liquid medium on canvas, 21 x $16^{5}/_{6}$". Harvard University Art Museums, Cambridge, Massachusetts; Bequest Collection of Maurice Wertheim, Class of 1906

PAGE 63: *The Song of the Dog*. 1876–77. Gouache and pastel over monotype on three pieces of joined paper, $22^{5}/_{8}$ x $17^{1}/_{8}$". Private Collection.

PAGE 64: *A Woman Having Her Hair Combed*. 1886–88. Pastel on light green wove paper, $29^{1}/_{8}$ x $23^{7}/_{8}$". The Metropolitan Museum of Art, New York; Bequest of Mrs. H. O. Havemeyer, 1929; The H. O. Havemeyer Collection

PAGE 65: *The Tub*. 1885-86. Pastel, $27^{1}/_{2}$ x $27^{1}/_{2}$". Hill-Stead Museum, Farmington, Connecticut

PAGES 67–68: *Waiting*. 1862. Pastel on paper, 19 x 24". Owned jointly by the J. Paul Getty Museum, Malibu, and the Norton Simon Art Foundation, Pasadena, California

PAGES 69–71: *Before the Ballet*. 1890-92. Oil on canvas, $15^{3}/_{4}$ x 35". The National Gallery, Washington, D. C.; Widener Collection

PAGE 72: *Ballet Dancer in Her Dressing Room*. 1878–79. Gouache and pastel on joined paper, $23^{5}/_{8}$ x $15^{3}/_{4}$". Oskar Reinhart Collection "Am Romerholz," Winterthur, Switzerland

PAGE 76: *At the Milliner's*. 1882. Pastel on pale gray wove paper, $29^{3}/_{4}$ x $33^{3}/_{4}$". The Metropolitan Museum of Art, New York; Bequest of Mrs. H. O. Havemeyer, 1929; The H. O. Havemeyer Collection

PAGE 78: Dancer of the Corps de Ballet, c. 1896. Photograph attributed to Edgar Degas. Bibliothèque Nationale, Paris

PAGE 79: *Resting*. 1876–77. Monotype in black ink on china paper, $6^{1}/_{4}$ x $8^{1}/_{4}$". Musée Picasso, Paris

PAGE 80: *Dancer Looking at the Sole of Her Right Foot*. 1900–10. Bronze, "Modele" cast, Bronze No. 69, height $19^{1}/_{8}$". Norton Simon Art Foundation, Pasadena, California

PAGE 82: *Green Dancer*. 1880. Pastel and gouache on heavy wove paper, 26 x $14^{1}/_{4}$". Thyssen-Bornemisza Collection, Madrid

PAGE 83 (detail): Edgar Degas in his studio, Rue Victor-Massé, c. 1898. Photograph attributed to Bartholomé. Bibliothèque Nationale, Paris

PAGE 85: *Landscape*. c. 1892. Pastel on paper, $16^{1}/_{2}$ x $21^{3}/_{4}$". Galerie Jan Krugier, Geneva, Switzerland

PAGE 87: Edgar Degas and his housekeeper Zoé Closier. Photograph attributed to René de Gas, 1895–1900. Bibliothèque Nationale, Paris

PAGE 88: Edgar Degas walking along the Boulevard de Clichy, c. 1914. Enlarged frame from the film *Ceux de Chez Nous* by Sacha Guitry.

PAGE 89: Anonymous. Photograph of Edgar Degas, c. 1915.

INDEX